East Anglia from the Air: Cambridge & Around

Martin W. Bowman

Prologue by Judge Ben Smith Junior

D1421606

AMBERLEY PUBLISHING

Martin Bowman is one of Britain's leading aviation authors and has also established an international reputation for his superb imagery and aerial photography. He lives in Norwich, Norfolk.

Ben Smith Jr is a lawyer and a judge in Waycross, Georgia. In the Second World War he was a technical sergeant radio operator/aerial gunner on a B-17 Flying Fortress crew in the 303rd Bomb Group at Molesworth, Huntingdonshire, and flew thirty-one combat missions. At the time of writing he is the last surviving crewmember on 'Chick's Crew'.

First published 2013

Amberley Publishing Plc
The Hill, Stroud
Gloucestershire, GL5 4EP

www.amberley-books.com

Copyright © Martin Bowman 2013

The right of Martin Bowman
to be identified as the Authors of
this work has been asserted in accordance with the Copyrights,
Designs and Patents Act 1988.

ISBN 978 1 4456 1890 6
E-BOOK ISBN 978 1 4456 1902 6

British Library Cataloguing in Publication Data.
A catalogue record for this book is available from the British Library.

Typeset in 10pt on 13pt Celeste.
Typesetting by Amberley Publishing.
Printed in the UK.

CONTENTS

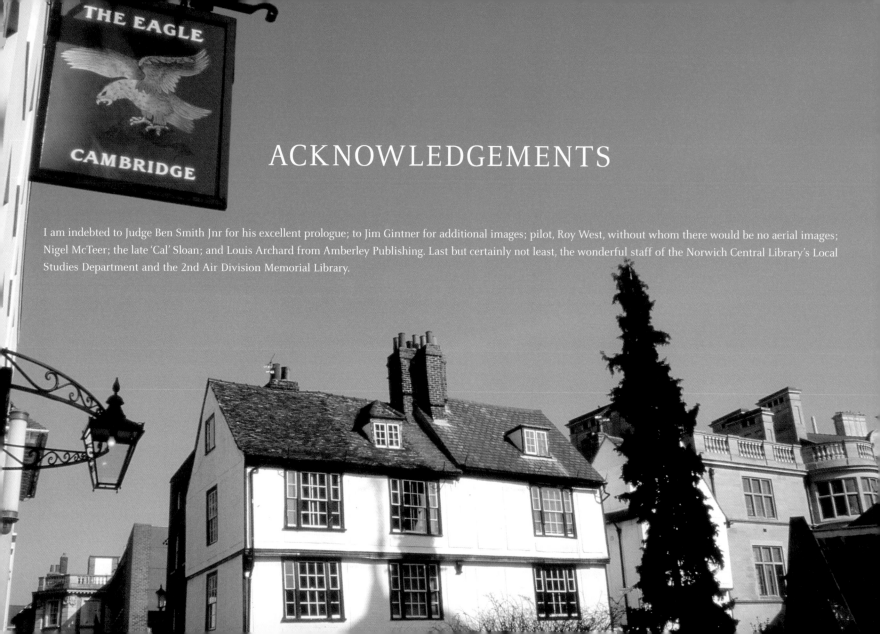

ACKNOWLEDGEMENTS

I am indebted to Judge Ben Smith Jnr for his excellent prologue; to Jim Gintner for additional images; pilot, Roy West, without whom there would be no aerial images; Nigel McTeer; the late 'Cal' Sloan; and Louis Archard from Amberley Publishing. Last but certainly not least, the wonderful staff of the Norwich Central Library's Local Studies Department and the 2nd Air Division Memorial Library.

PROLOGUE BY JUDGE BEN SMITH

It was near the end of my tour [during the Second World War] that I obtained a three-day pass and first visited Cambridge. It was only about 20 miles from Molesworth. I fell in love with the place. Its fine old Gothic buildings, many of them dating from the thirteenth and fourteenth centuries, were deeply satisfying to me. I could not get enough of roaming its medieval streets. Everyone walked or rode bicycles; the streets were almost too winding and narrow for automobiles. Here the timbered veneers of Tudor England were very much in evidence. Some of the houses and inns were many centuries old. The university owned all the land thereabouts and they did not countenance any of the tomfoolery called progress. They wanted Cambridge left just as it was; a decision I would have to applaud wholeheartedly.

The university was made up of a number of colleges, each having its own identity, such as Queen's College, Trinity College, St John's College and the like.

I learned that in ancient times Cambridge had been a monastic establishment built in the fens of East Anglia. Eventually it began to be a center of learning. It was already a great university when it was visited by the great Erasmus, the foremost prophet of the Reformation. He came to Cambridge in 1500 and remained there at Queen's College for three years.

The finest of the medieval edifices was King's College Chapel, begun in 1446. With its inspired fan vaulting, it was the supreme example of the perpendicular Gothic. I had only a rather general understanding of the decorative vocabulary in those days, but there were many knowledgeable people who were glad to explain these things to me.

The loveliest area of all was that part of the university called The Backs, where the tree-shaded lawns and gardens ran from the backs of the colleges down to the picturesque River Cam from which the town derived its name. I strolled along the grassy banks of the green river with its weeping willows and ancient stone bridges and thought to myself, 'This is the loveliest spot in the world.'

I happened upon a cricket match and was fascinated. The players were immaculate; it seemed a very antiseptic sport to me, but as I watched I could see that a lot of coordination and agility were being displayed. I never did fathom what was going on despite a friendly bystander's attempts to tell me.

The Backs had once been marshes but in the seventeenth century had been filled in by Oliver Cromwell, the Great Protector, to become the beautiful garden spot that one now sees. A great summer fair had been held annually on the Commons in olden times. The Commons was a great grassy expanse near the river. Here the stout English yeomen had come from every part of the Midlands and East Anglia to socialise, carouse, shoot their longbows in competition and vie with each other in feats of strength. Farmers, merchants and artisans hawked their wares on all sides, drinking and wenching betimes. It was said that the fair was the model for Vanity Fair in Bunyan's *Pilgrim's Progress*. It was a lusty, brawling time. Now a hearty new breed had invaded the Commons. The Yanks were to be seen everywhere, intruding a jarring note upon the timeless, pastoral scene.

I wandered again along the banks of the Cam and saw an apple-cheeked underclassman poling a punt down the meandering stream. His passenger, an

upperclassman, was eating an apple and reading a book. Being an American, I did not understand why the boatman was not rebelling at the supine role he was forced to play. This custom, which to me seemed an anachronism, had wide acceptance, going unchallenged by the underclassmen. But who knows what noble concepts had germinated in these verdant surroundings? Here the young Tennyson might have dreamed dreams, which became *The Idylls of the King*, or the youthful Charles Darwin might have explored broad vistas of the intellect, which eventuated in the *Origin of Species*.

Since the Middle Ages, Cambridge had been a market town. Farmers from the surrounding country brought their vegetables and produce to the great open market place behind St Mary's Church. A lively place, it held great fascination for me, as I had never seen an open-air market before.

What a delight to rest in an ancient inn drinking the excellent light brown ale! While chatting convivially with the other customers, I exulted in a milieu of Jacobean tables and chairs, mullioned windows, exposed ceiling beams, rich dark oak wainscoting, an open-hearth stone fireplace and finally church warden pipes on the wall, not added as a decorator's touch but centuries old and once used by the patrons of the inn – a jewel of a setting for one who needed no such encouragement to drink. Had this genteel place once been the favourite haunt of Edmund Spenser or John Milton? Had the youthful Wordsworth and his friend Coleridge sat in these very chairs quenching their thirsts from the lovely, old pewter tankards? I did not know, but I did not doubt it, for this was a place of poets.

The next morning I resumed my exploration of the old medieval town. In the narrow streets I saw the handsomest shops I had ever seen. I had a thing about bookstores and here was the oldest one in England, Bowes & Bowes founded in 1581. Bookbinding had been a major craft in Cambridge for centuries and the shop was a treasure-trove of handsome and rare volumes. Moving along, I was delighted to find a shop that had an amazing collection of jazz records. The proprietor told me that the college students and many of the professors not only loved jazz, but there were many connoisseurs of the idiom at the university.

These were collector's items, some of which could not be found at home. I bought an album of a recording session by Louis Armstrong and Earl 'Father' Hines, featuring the venerable 'West End Blues' and 'Tight Like That'. This was really vintage jazz and I was amazed to find it in this place. It only increased my esteem for the kind of people to be found hereabouts.

I had seen the genius of Sir Christopher Wren at St Paul's and St Mary-le-Bow in London. I hadn't realised he was here also. The outstanding examples of his art in Cambridge were the magnificent Wren Library at Trinity College and the Emmanuel College Chapel. There were many quaint churches in the city. I was fond of poking and prowling about the graveyards. I was no necrophile, but the epitaphs on the tombstones were an unending source of delight to me. I sought out these places. They did not depress me. On the contrary, I rather fancied the idea of resting in one of these lovely old churchyards one day, for they did not seem like places of death to me but rather fitting ambiences for departed spirits.

And now I began to understand why Cambridge held such fascination for me. I had been looking for a place like this all my life. I felt that I was part and parcel of this greatest outcropping of the human spirit. In those days I only dimly understood the great thirst of the spirit that was growing in me, but I sensed that somehow in this place was the repository of every value that I held near and dear. My very soul sped across the centuries to unite with the antique refrain of the old medieval town.

In desperation I began to think of ways that I could manage to stay here. It seemed logical that every human being should be in a place where he was contented and happy and safe. I was in such a place. Here in this green Eden was peace and sanctuary. The apparatus of death and terror was in ceaseless operation 20 miles away, but now it seemed to have nothing to do with me. I did not want to be wasted just as I had begun to catch a vision. I knew that I belonged here. The other Americans did not care about this place, but I did. So my mind raced – was there a way? In the end I knew it was no good – I had to go back to Molesworth and finish the other business, one way or the other. It would have been better had I never come to Cambridge. Sadly I turned my back on the place and boarded the bus.

Judge Ben Smith, 1944, adapted from *Chick's Crew*.

Above: Ben Smith.

Right: 'The streets were almost too winding and narrow for automobiles' – Trinity Lane.

INTRODUCTION

There are almost thirty Cambridges throughout the globe but Cambridge in England is world renowned for its magnificent university buildings, which display seven centuries of architectural heritage. The University of Cambridge is made up of thirty-one colleges yet at the start of the thirteenth century Oxford was the only university in Britain. Unlike modern campuses, Cambridge (and Oxford) consist of autonomous colleges whose separate sites are scattered throughout the town. All students are associated with a college and most live within its precincts

Cambridge stood at the point where forest met fen, at the lowest fording point of the river. The Romans took over a site previously settled by an Iron Age Belgic tribe and the Saxons and the Normans followed this in turn. Cambridge's major importance was due to its position at the head of navigation on the River Cam, or Granta as it was known originally, making it an ideal trading centre. When the college buildings did start to appear it was this position on the Fenland waterways that permitted use of building materials not normally found in the region.

Cambridge flourished as a market and river trading centre and in 1209 a group of students fleeing riots in Oxford arrived. Some were charged with murder and were hanged in Oxford by the townspeople, with the approval of King John. Oxford and Cambridge were the only two English universities for 600 years.

By the mid-thirteenth century Cambridge was recognised as a university, even though it had no buildings of its own. Tutors would lecture in borrowed halls and churches, while their students took what lodgings they could in the town. They would frequent the taverns, get drunk and cause disturbances, often upsetting the townsfolk. In the late thirteenth century, the earliest colleges were set up as permanent places for scholars to live, study and pray. In 1284, the first college was built next to a church called St Peter's and became Peterhouse. In medieval times, students would enter the university at the age of fourteen and remain until they were twenty-one, or sometimes older. The minimum seven-year course culminated in an MA or BA degree. In the sixteenth century, eight more colleges were founded in succession before a lull of nearly 100 years. Five of the colleges were founded mostly as a result of Henry VIII's dissolution of the monasteries (1536–40) but the Tudor times were marked by the execution of five university chancellors 1535–1600.

In the seventeenth and eighteenth centuries many new and larger libraries were built as places to study and to store an ever-increasing number of books. Libraries were usually on the first floor to avoid the damp and floods. They were also aligned from east to west to receive as much sunlight as possible. By the early twentieth century the University Library had become too cramped on its existing site in the Old Schools, where it had first opened in 1438, and in 1934 a new library was built, designed by a leading architect of his day, Sir Giles Gilbert Scott, who also designed the Bankside Power Station in London (now the Tate Modern).

By the mid-nineteenth century, Cambridge's population numbered around 30,000 people, with the parishes of Trumpington, Cherry Hinton and Chesterton still separate from the town. Living conditions were far from ideal, with open

drains in the streets and the Cam little more than a sewer, while many townsfolk lived in slum accommodation. But the arrival of the railway in the 1840s brought not just more people, but also industry and housing.

In the 1930s and during the Second World War, Cambridgeshire was dotted with a large number of mainly bomber airfields, which were used by the Royal Air Force and later by the US Eighth Air Force. Thousands of aircrew personnel on leave and 'R&R' descended on Cambridge to have a good time.

Many students who have passed through the university throughout the ages have helped shape events in world history. The celebrated and distinguished alumni include Oliver Cromwell, Isaac Newton, Byron, Tennyson, Milton, Wordsworth, Marlowe, Bacon, Samuel Pepys, Charles Darwin, Charles Babbage, Bertrand Russell and Ludwig Wittgenstein. Alan Turing, one of the cryptologists who cracked the Enigma code in the Second World War, was at King's, first as an undergraduate then as a Fellow, and wrote the seminal paper *On Computable Numbers* here.

The Apostles is a famous and secret debating society. Its members are elected for life. The society was started in 1820 and early members included the poet Lord Tennyson. The Apostles had a particularly brilliant period in Edwardian times, when many topics such as religion were furiously discussed. They wore outrageous clothes and behaved in a way that the strict Victorians would have found quite shocking. Members of King's challenged the intellectual ideas, as well as the social rules, of the day. Members have included eminent politicians, writers, scientists and even infamous spies. While at Cambridge in the mid-1930s Guy Burgess, Donald Maclean, Kim Philby, Anthony Blunt and John Cairncross – all gifted undergraduates – were recruited as spies by the KGB. Four of the 'Cambridge Five' went to Trinity. Some famous members of the Apostles were Edward Morgan Forster, a novelist, who arrived at King's in 1897; Rupert Brooke, who came up in 1906; John Maynard Keynes, an economist; Bertrand Russell, G. E. Moore and Ludwig Wittgenstein, philosophers, and Giles Lytton Strachey, a writer. Keynes's ideas directly influenced President Roosevelt's New Deal in the USA in 1932. Rupert Brooke's exceptional good looks and his poetry were legendary. Rupert Brooke was a Fellow at Cambridge; eager to fight for his country, he joined up as an officer in 1914. He died near Gallipoli in 1915.

While farming is still a major industry in the area the centre of Cambridge retains its spirit of a market town its grand college buildings, narrow streets and alleyways, peaceful open greens and the Cam make it unique among British towns and cities. Science parks have sprung up around Cambridge and made the area the so-called 'Silicon Fen', a concentration of companies and organisations specialising in computer technology, many of them benefiting from the research carried out at the university. The Nobel Prize has been won over sixty times by Cambridge scientists (twenty-nine from Trinity alone) between 1901 and 2001.

Martin W. Bowman

King's, Trinity Hall, Clare and St Catharine's.

MADINGLEY AND CAMBRIDGE AT WAR

'The war wasn't all work and no play. From time to time, we would go into town. Our two social cities were Cambridge and London. Cambridge is known for its colleges and for punting on the Cam but what most of us GIs' remember was the very popular 'Dorothy' Dance hall. There were plenty of girls to dance with at the 'Dorothy'. The place was always jumping, especially on a Saturday night. I guess the English girls needed to have a little fun and they sure did love to dance. We had a number of weddings as the result of these get-togethers at the 'Dorothy'.'

Larry Nelson, a P-47 Thunderbolt pilot in the 78th Fighter Group at Duxford

Madingley
A gift from Cambridge University to the American Battle Monuments Commission, the American Military Cemetery, Madingley, represents every service from the US Coastguard to the Marine Corps and every theatre of the war in Europe, from North Africa to Normandy. Every state too is represented.

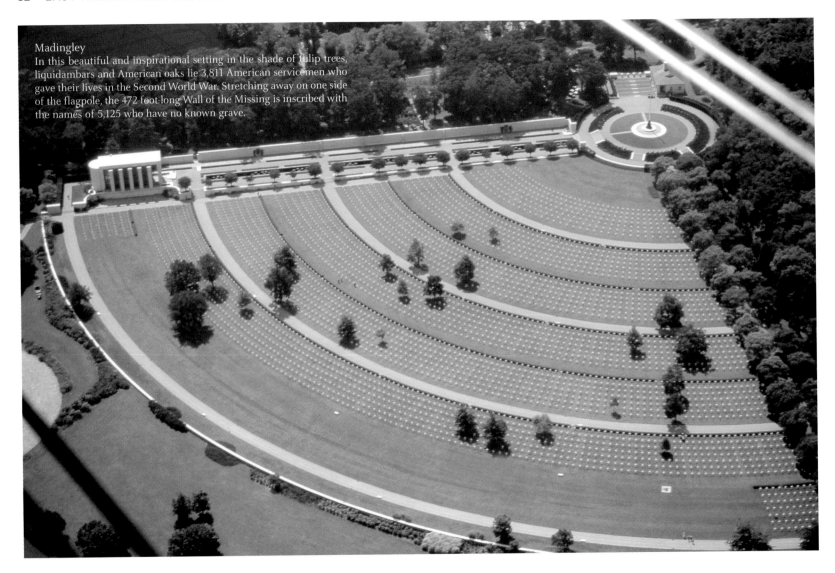

Madingley
In this beautiful and inspirational setting in the shade of tulip trees, liquidambars and American oaks lie 3,811 American servicemen who gave their lives in the Second World War. Stretching away on one side of the flagpole, the 472-foot-long Wall of the Missing is inscribed with the names of 5,125 who have no known grave.

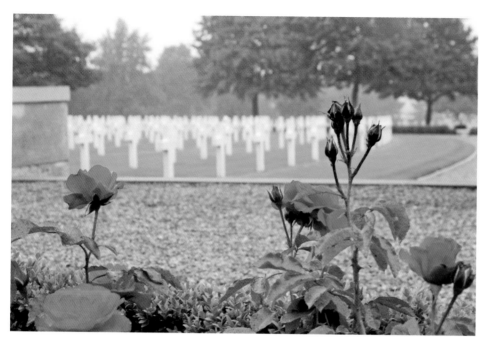

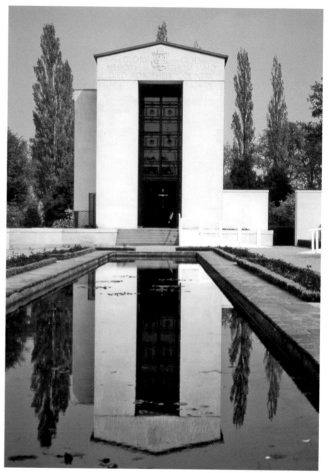

Above: A gound level view of Madingley Cemetery.

Right: The memorial chapel at Madingley.

'Bomber station in England, June 28, 1943 – The days are very long. A combination of summer time and daylight-saving time keeps them light until eleven-thirty. After mess we take the Army bus into town. It is an ancient little city which every American knows about as soon as he can read. The buildings on the narrow streets are Tudor, Stuart, Georgian, and even some Norman. The paving stones are worn smooth and the flagstones of the sidewalks are grooved by ages of strollers. It is a town to stroll in. American soldiers, Canadians, Royal Air Force men; women soldiers – driver-mechanics, dispatch riders, trim and hard in their uniforms.

The crew of the *Mary Ruth* ends up at a little pub, over-crowded and noisy. They edge their way in to the bar, where the barmaids are drawing beer as fast as they can. It is not cold. They sip the flat, tasteless beer. A mixed group of pilots and ATS girls at the other end of the pub have started a song. It is astonishing how many of the songs are American. '*You'd Be so Nice to Come Home To*', they sing. And, the beat of the song is subtly changed. It has become an English song.

They stand up and file slowly out of the pub. It is still daylight. The pigeons are flying about the tower of an old Gothic church, a kind of architecture especially suited to nesting pigeons.

The hotel taken over by the Red Cross is crowded with men in from the flying fields which dot the countryside. Our bus drives up in front and we pile in. The crew looks automatically at the sky. It is clear, with little puffs of white cloud suspended in the light of a sun that has already gone down.

'Looks like it might be a clear day,' the radio man says...

Once There Was A War by John Steinbeck (1943). It relates to the crew of *'Mary Ruth' Memories of Mobile*, captained by Lieutenant Kenneth L. Brown of the 91st Bomb Group at Bassingbourn, one of many USAAF and RAF units based near Cambridge. The fortress *'Mary Ruth'* and Brown and his crew failed to return on 22 June 1943.

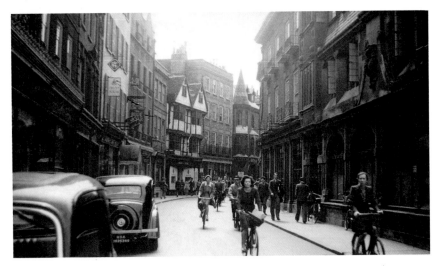

Trinity Street from the King's Parade end. (George Parker)

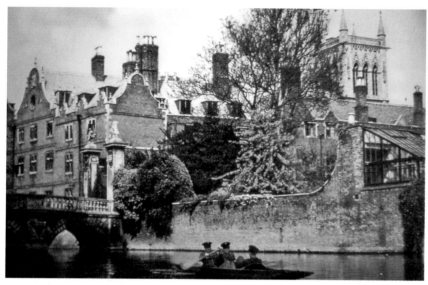

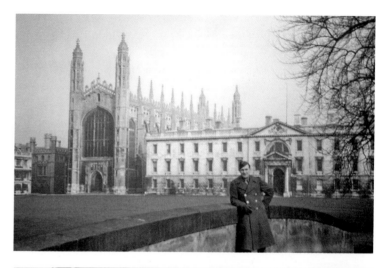

Above: GIs punting on the Cam near Wren's Bridge.

Above right: Private Alex C. 'Cal' Sloan, a GI at Steeple Morden in the Second World War, on King's Bridge over the Cam. The Provost often recounted the history of King's College to American guests invited from bases in East Anglia. (Sloan)

Right: The Baron of Beef on Bridge Street, a popular haunt of RAF aircrew in the Second World War.

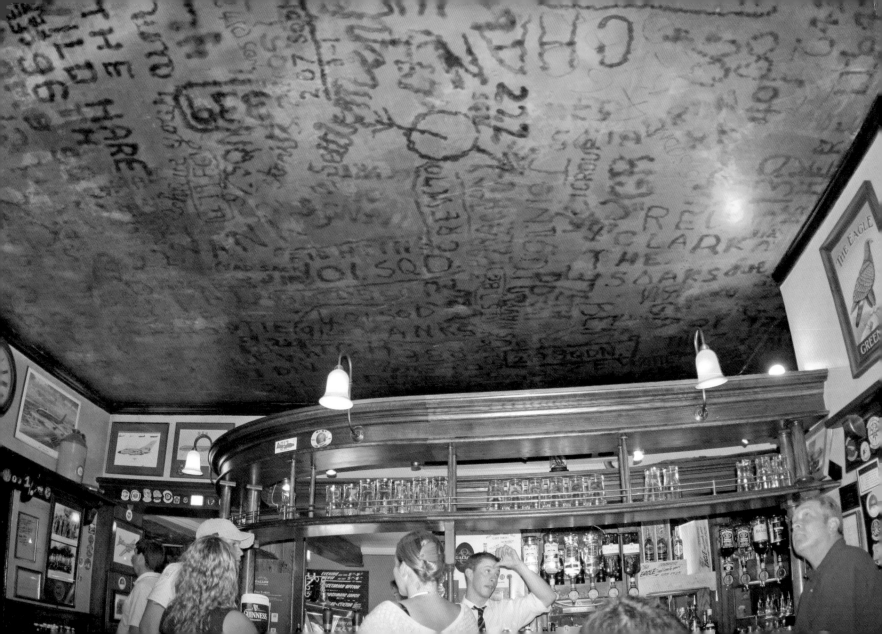

The ceiling in the RAF bar at The Eagle in Bene't Street dates from the Second World War, when the inn was used by British and Allied airmen, and is covered with names and squadron numbers written in candle smoke.

Secrets of the Ceiling 'The Eagle'

Once more 'The Eagle' will open its doors
The loss of its yard, we shall deplore,
Pillars there are eight,
Also a log-burning grate.
John Wiseman and wife were former hosts
Of occupants three are ghosts
The lounge ceiling – so revealing
To read became appealing.
Its words were a mystery,
Such a chequered history,
Its stories are folk lore,
Of fighting men no more.
The stories of the RAF, so great
And also of 'the Mighty Eighth'
By candle and lighter, the stories unfold
That those who came later may be told.
The runways now are stilled
But the ceiling here is filled,
It is the story of the places
That became known as local 'bases'.
The army too was there,
Many divisions were to share,
The space on the ceiling grew very short,
As many writers came to report.
The navy came and left an 'anchor',
Some of the writing could not be franker,
Of Pathfinder Squadrons there are six,
As many brave men came to mix.
'Secret Squadrons', there were two,
And from a field at Tempsford flew,
514 – and many more
All came to make the score.
A VC on 218, three B-17s of the 'Eighth'
Weather, photo and rescue,
Are all there to view,
Squadrons of the Gallant 'Few', 222 and 92,
156, 83 and 7; also the badge of 97,
As food in Berlin came to be short,
The Squadrons of the 'Airlift' made it a port.
In the smoke and grime of passing time.
A nude lady so sublime,
These are the SQUADRONS, now no more,
Who flew the troubled skies of '44'.
James Chainey

'SOMEONE once said that the River Cam along the 'backs' was the most beautiful half-mile in England. Standing now on the carpet of green lawn of King's College on that bright June afternoon, I was in no mood to disagree. Here, if anywhere in England, was a spot where tradition, architecture, history and landscape blended into a perfect, harmonious whole. Here was the past in the magnificent old chapel and the perfect classic proportion of the adjacent Clare; here was age and beauty. Here, too, overhead was the present, as British bombers wheeled and manoeuvred in the afternoon sunlight. Here, too, was the future, walking about the courtyard in the uniform of air cadets - talking from window to window across the court - lazing idly at the riverbank. Here all ages met.

Cambridge University, if you excepted the sky above it, which invades all sanctuaries, was an island of peace and contemplation set in the stormy sea of war that swirled around Eastern England. The streets of the town were crowded with British airmen, WAAFs; farmers come to market, Americans who flocked to their club in the Bull Hotel. But once inside those massive iron gates, you left the noise and hurly-burly of the world outside; you entered a cloistered, ordered and somehow a remote world where every stone and every blade of grass cried out 'I belong here...just here!'

Though it was between terms and most of the students were gone, I enjoyed that walk around the university grounds and through the quiet courtyards. Here was the ancient Elizabethan brick of Queen's, here was old Trinity with its host of famous names, here was the dark, crumbled stone of Magdalene...raftered dining halls with their carved oak tables black with age and their ancient nameless portraits on the walls. Here was a place for a young man to live and let history and knowledge and manners seep into his skin and run in his blood. Here while he studied he could see for himself the qualities that had slowly brought this gem to England and England its prominence in the world. He need not be taught English history here - it was all around him and if he listened he might still hear the whispered voices of Wordsworth and Newton, Darwin and Pitt, Cromwell and Milton and perhaps even Chaucer!

You couldn't help doing some thinking here at Cambridge - and that, I suppose, is just what it is for.

Thoughts At Cambridge, **Robert S. Arbib Jr.**

Opposite: St John's College (foreground) with the Quayside and Magdalene Street Bridge, or Great Bridge (bottom left) and Jesus College (top). Just to the left of St John's College chapel is the Round Church in Bridge Street, originally called the Church of the Holy Sepulchre; there are only four complete round churches like this in England. The Fraternity who constructed it early in the twelfth century were influenced by the first round Christian church built by the Roman Emperor Constantine around the site of Christ's tomb in Jerusalem, using thick pillars and rounded arches.

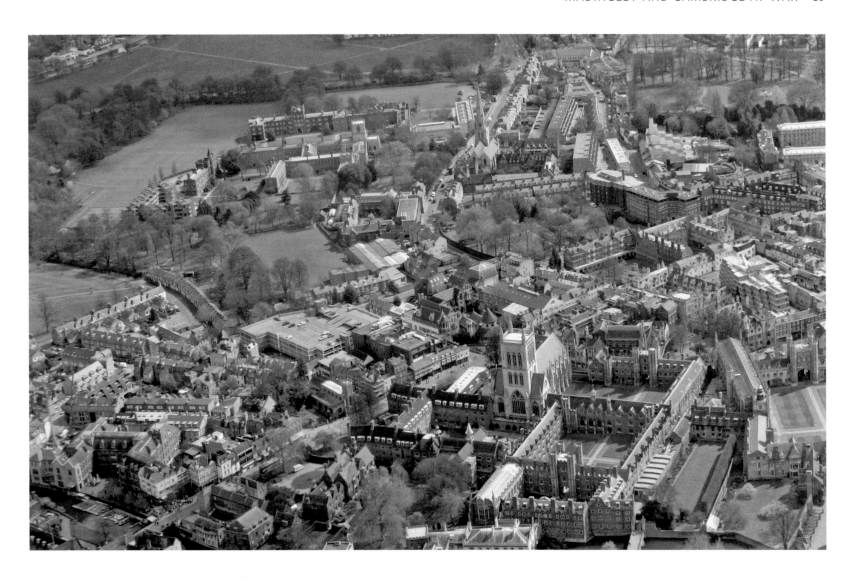

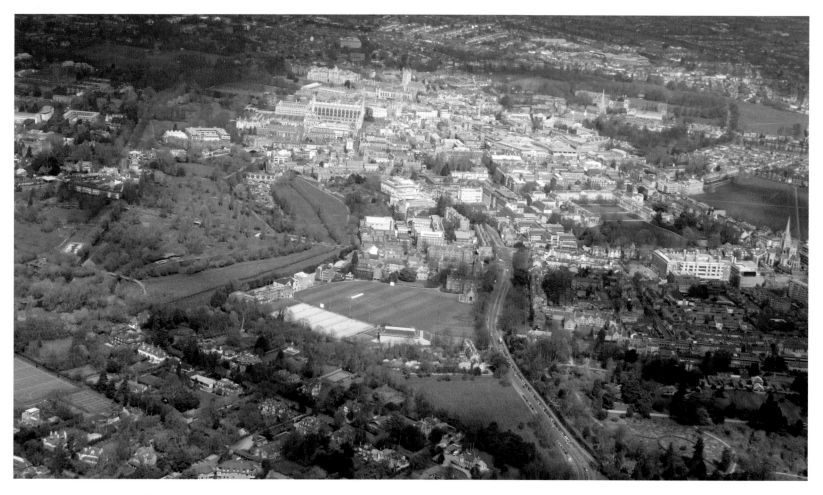

Centre of learning. There are almost thirty Cambridges throughout the globe but Cambridge in England is world renowned for its magnificent university buildings, which display seven centuries of architectural heritage. Only from the air does the extent of the colleges, commons and parks become obvious. In the foreground is the Cambridge University Botanic Garden, established by Charles Darwin's teacher Henslow, which now has over 8,000 plant species; Coe Fen (left) and the Backs. Right is Parker's Piece. Top right are Jesus Green and Midsummer Common.

Part 2

CAMBRIDGE

What can I say about Cambridge? How can I begin to speak of its beauty, to me the fairest on earth? First we went to King's College Chapel and heard Evensong. Where the boys' choir comes from I don't know, but it must be one of the very best in England. After the service was over we watched the choirboys in Eton collars and toppers, with umbrellas neatly furled, march out of the chapel, cross the Cam and disappear. 'Perhaps they live in trees, like the birds,' Bernard suggested. We had a long ramble through the colleges and then got a boat and spent a couple of hours on the river. I rowed upstream, while Bernard manned the tiller and we exchanged places coming downstream. It was one of those afternoons when one sees the English summer at its very best and I would willingly endure a fortnight of the worst of English climate has to offer, to be rewarded at the end of the day of such limpid perfection. The river was crowded with American soldiers who were snarling up traffic in a hopeless way, but the air was so full of good humour and high spirits that no one seemed to mind the immediate danger of capsizing.

Drifting lazily downstream we heard the bells of St. Mary's ringing the changes, while we saw the buildings at their most beautiful. It seems to me that I reached the very summit of human happiness during those sun-lit hours on the Cam.

We walked along the Backs beside the Cam with the warm spring sunshine lying like a haze over the river and the lawns and the mellow buildings. I walked through college after college, heedless of their names and in a trance of wonder at the beauty all about me. I am, I fear, given to strong prejudices. That afternoon I formed the conviction, strengthened by many subsequent visits, that if there is anything this side of heaven more beautiful than Cambridge as seen from the Backs on a sunny spring or summer day, I just don't want to see it. Cambridge will do for me.

Suffolk Summer, John T. Appleby

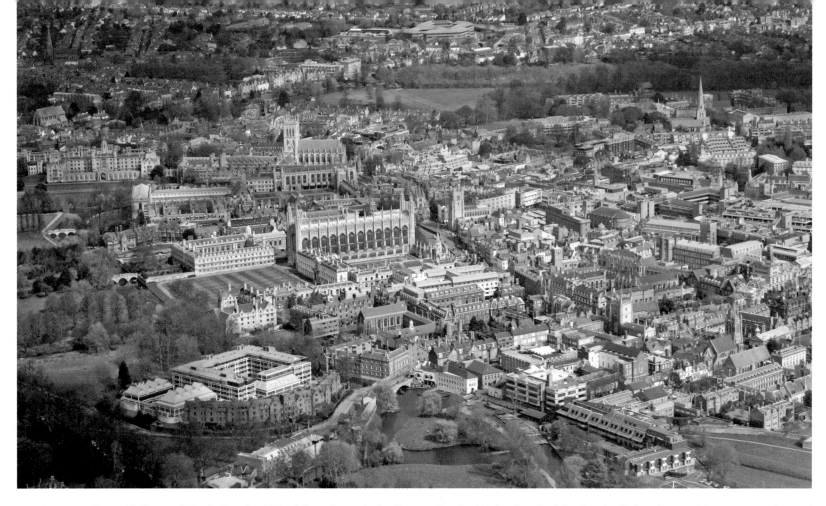

Learning curve. Queens' College and King's Chapel, with its delicate fan-vaulted ceiling running the 289-foot length of the chapel, which took over 100 years to complete and was presided over by five kings of England. St Catharine's (centre). At the foot of the picture (left) in Silver Street are Darwin College and the Fisher Building, built 1935–36; described by Nikolaus Pevsner as 'looking exactly like a friendly block of flats at, say, Pinner. Its Tudor style is not positively offensive and the broken shape round the corner into Queen's Road helps it.' Darwin, which has wonderful views over the Cam, was set up in 1965 by Caius, St John's and Trinity colleges for Fellows and postgraduates only (as is the case with Wolfson) by taking over early-nineteenth-century houses, notably The Hermitage and Newnham Grange. George Darwin, a distinguished don (university teacher) and Professor of Astronomy and son of Charles Darwin, was one of the first Fellows to move out from college rooms, marry and set up a family home – at Newnham Grange. Far right is Peterhouse the first and smallest of all the colleges (with about 300 students).

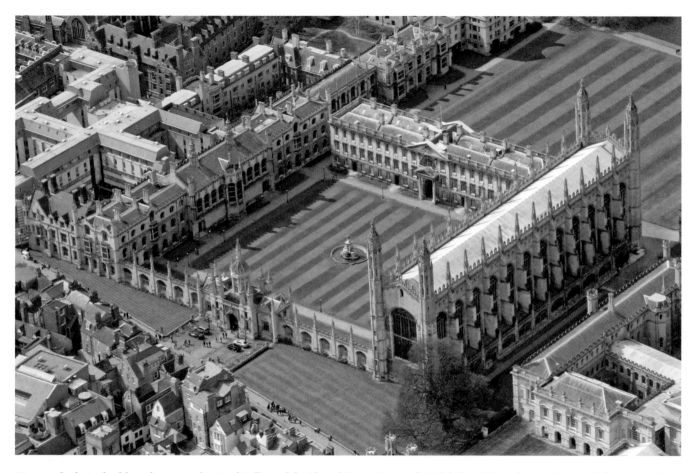

Kings go forth. In the fifteenth century the Royal College of the Blessed Virgin Mary and St Nicholas of Canterbury, subsequently known as King's, were founded by Henry VI. The monarch had already established Eton College in Windsor and the Royal College would have its scholars drawn from there. As with Eton, Henry's first concern was the establishment of a chapel, the design of which would be modelled more on the lines of a cathedral choir rather than the buildings typical of college chapels so far. The King's master mason, Reginald of Ely, was appointed as architect and building began in 1446 but it came to a premature halt with the Wars of the Roses. King's College Chapel was far from complete when Henry VI lost the throne in 1461 and it was left to Henry VII to oversee the finishing touches in 1513.

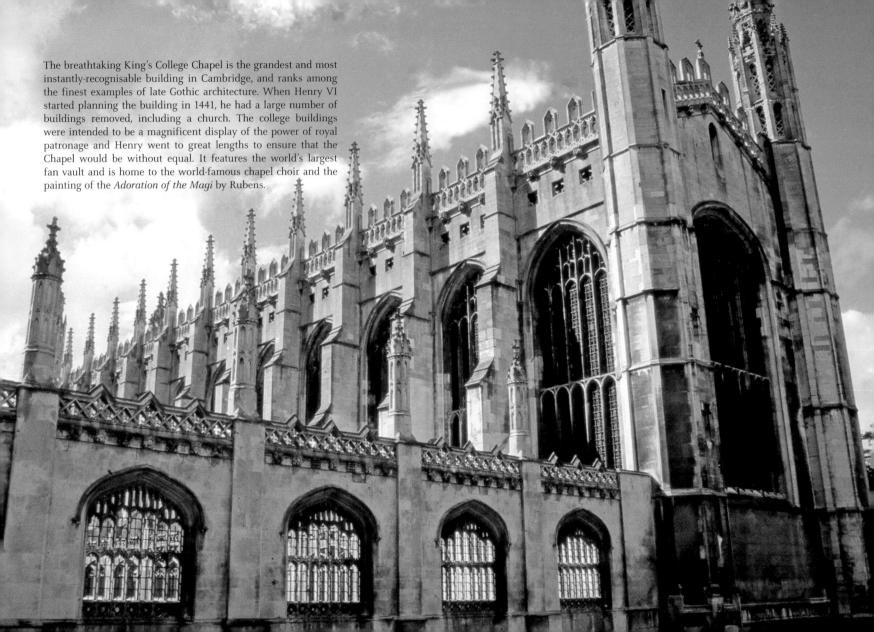

The breathtaking King's College Chapel is the grandest and most instantly-recognisable building in Cambridge, and ranks among the finest examples of late Gothic architecture. When Henry VI started planning the building in 1441, he had a large number of buildings removed, including a church. The college buildings were intended to be a magnificent display of the power of royal patronage and Henry went to great lengths to ensure that the Chapel would be without equal. It features the world's largest fan vault and is home to the world-famous chapel choir and the painting of the *Adoration of the Magi* by Rubens.

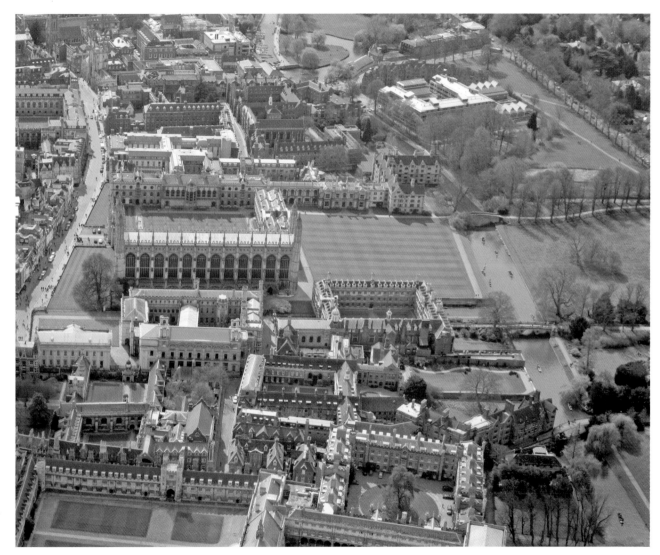

King's, with Clare to the right. In 1326 University College was started and it was refounded as Clare College in 1338 by Lady Elizabeth Clare. The foundress was widowed three times and, as a symbol of her grief, gold teardrops on a black band surround the arms of the college. Clare is the second-oldest college in Cambridge and is notable for its beautiful gardens, which are open to the public. Former members include Sir David Attenborough, James D. Watson, co-discoverer of the structure of DNA, and Protestant reformer Hugh Latimer.

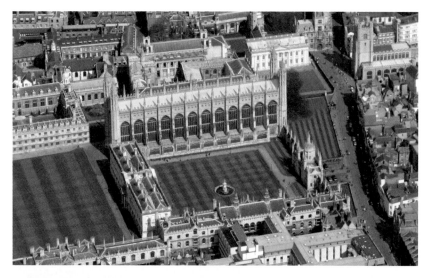

Left: King's and Clare.

Below left: Clare College.

Below: Porters' Lodge.

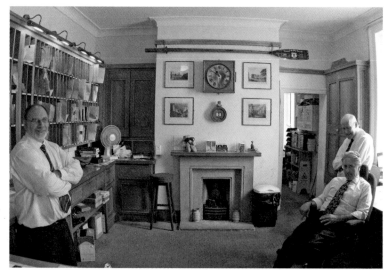

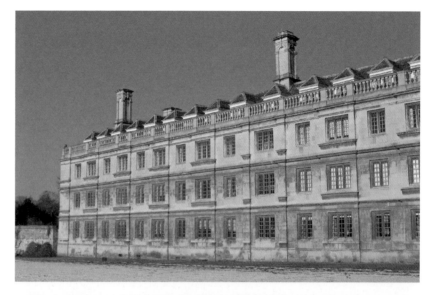

Clare in winter. (Jim Gintner)

Clare in spring.

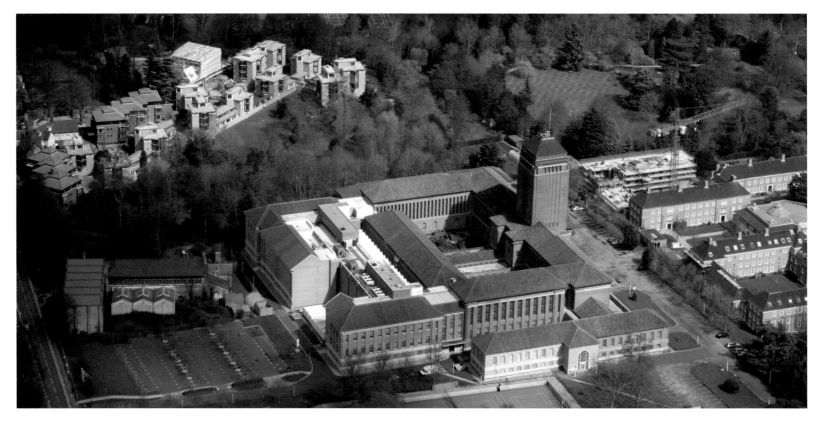

Above: University Library (built in 1934), with Clare College's Memorial Court (right). The library was designed by Sir Giles Gilbert Scott who also designed the Bankside Power Station in London (now the Tate Modern) and it was considered extremely shocking, particularly with its large, box-like tower. As one of only five 'copyright libraries' in the country it can claim a free copy of every book published in Britain – from *A Brief History of Time* to *Winnie the Pooh*. Behind the library stands Robinson College, the most recent college to be founded (1977), which is entirely funded by Sir David Robinson a local-born millionaire who gave the university £18 million to set up a new college. A new maternity hospital for the city was named after his mother Rosie and opened in 1983.

Opposite: King's, Clare and the Backs. Someone once said that the River Cam along the Cambridge 'backs' was the most beautiful half-mile in England.

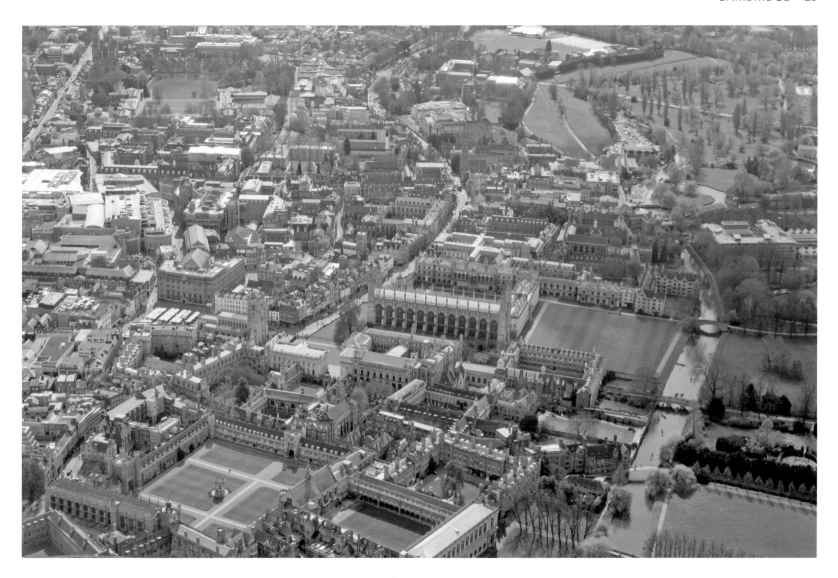

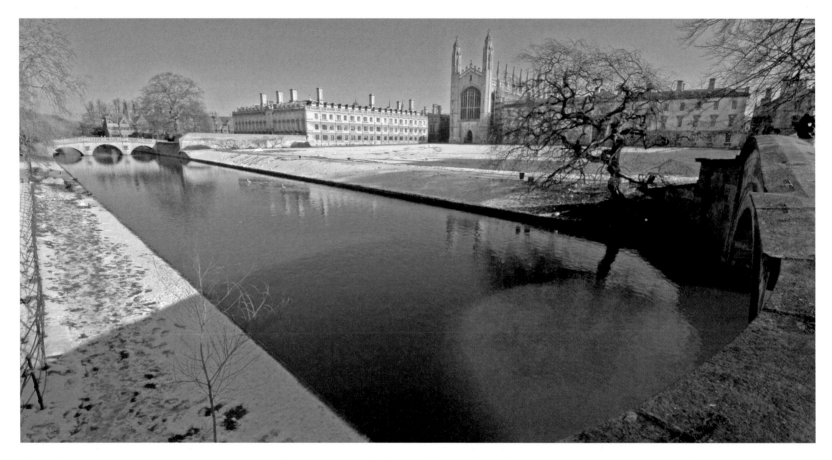

Above: Backs in winter. Clare Bridge (left), leading to Scholar's Piece, was built between 1638 and 1640, and is the oldest surviving bridge in Cambridge. At first glance it seems that there are fourteen stone balls on the balustrades but on closer inspection there are actually 13⅞. (Jim Gintner)

Opposite: The Backs and Mill Pond. Newnham Mill, a short distance upstream from the weir (at the end of Queen's Road, right), where corn was first milled in 1550 is now a restaurant complete with waterwheel. Left of centre is St Catharine's. In 1473 Robert Woodlarke, the third Provost of King's, founded St Catharine's (named after the patron saint of learning). None of the original buildings survive and most of the structure, including the magnificent dining hall, is seventeenth-century or later. The chapel houses a memorial to one of its more famous alumni, John Addenbrooke, whose bequest founded the county hospital.

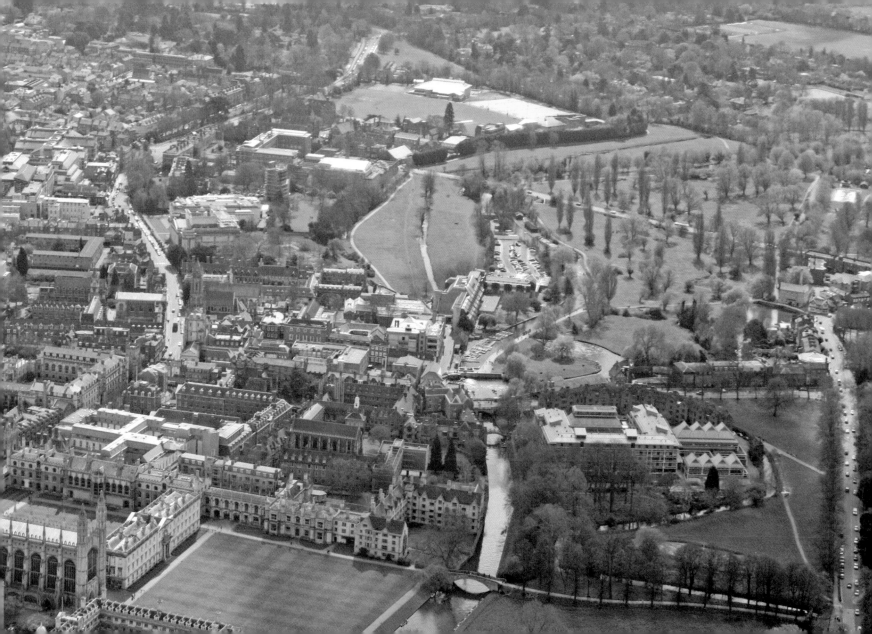

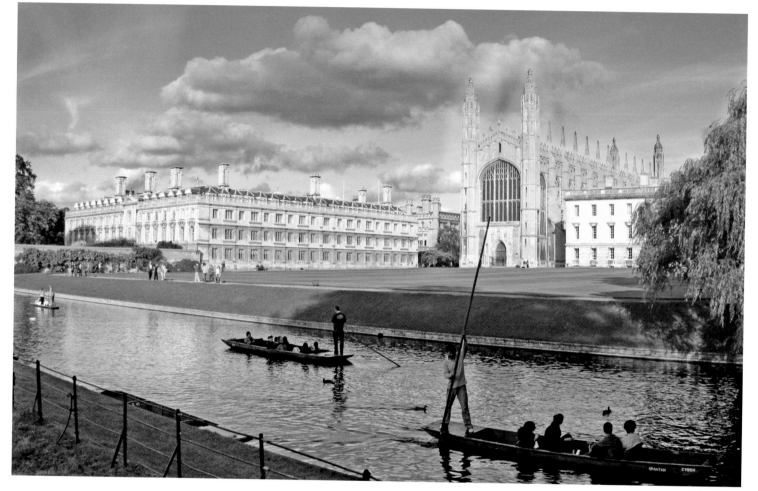

Above: Punting on the 'Backs' of the Cam brings a unique view of many of the colleges and passes under six bridges.

Opposite: The Backs and the cluster of colleges and the city.

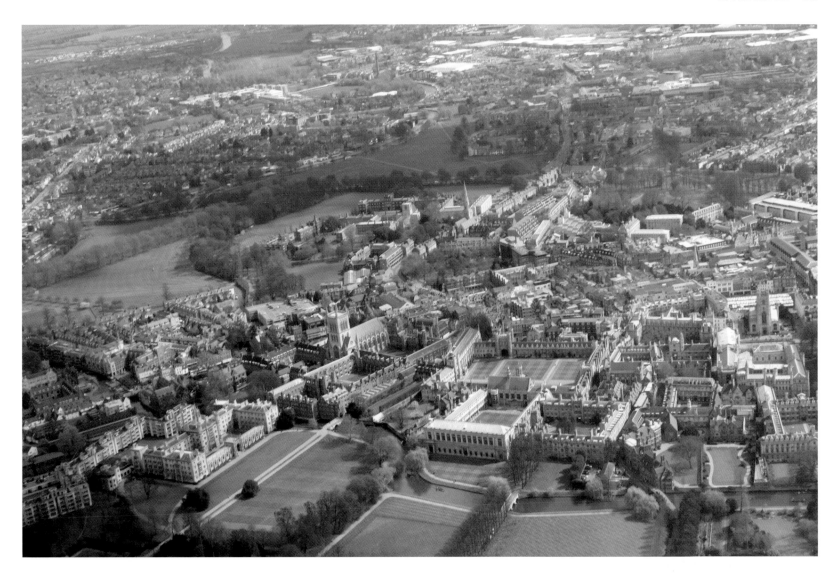

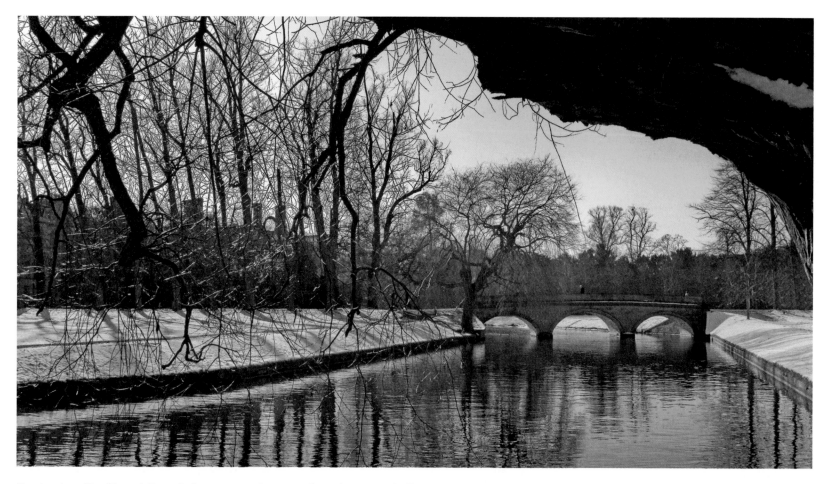

Cam in winter (Jim Gintner). From the late seventeenth century, the Backs were gradually transformed from garden plots, orchards and marshland into landscaped gardens. The Master of Trinity College, Richard Bentley, had the land leading down to the river drained and made into lush meadows. It was later planted with weeping willows and avenues of lime trees.

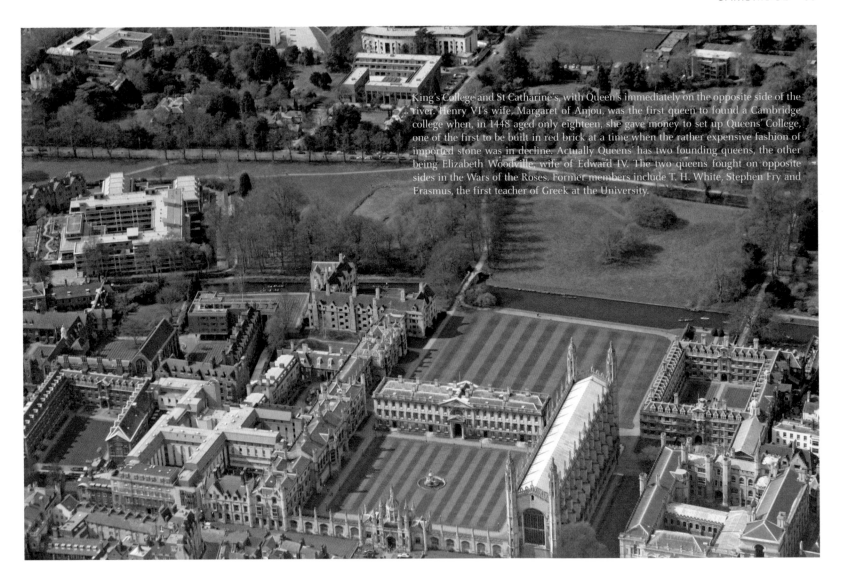

King's College and St Catharine's, with Queen's immediately on the opposite side of the river. Henry VI's wife, Margaret of Anjou, was the first queen to found a Cambridge college when, in 1448 aged only eighteen, she gave money to set up Queens' College, one of the first to be built in red brick at a time when the rather expensive fashion of imported stone was in decline. Actually Queens' has two founding queens, the other being Elizabeth Woodville, wife of Edward IV. The two queens fought on opposite sides in the Wars of the Roses. Former members include T. H. White, Stephen Fry and Erasmus, the first teacher of Greek at the University.

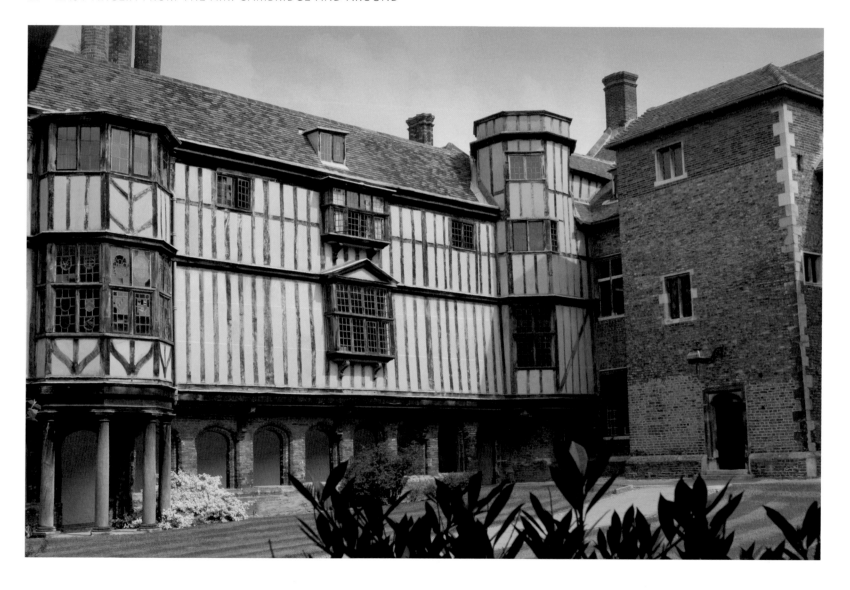

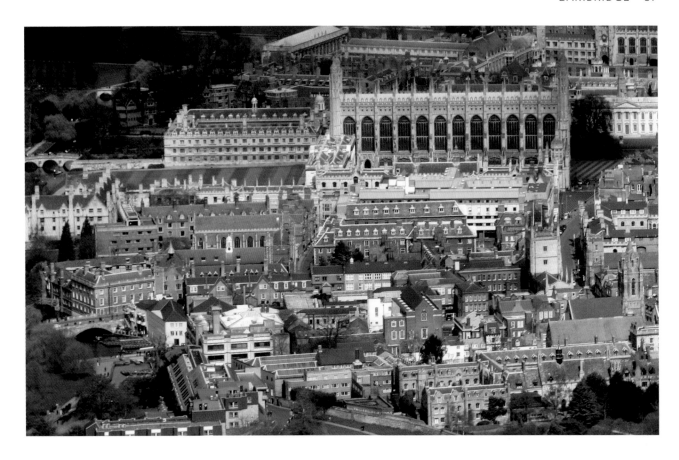

Queen's with King's College Chapel and Clare behind.

Opposite: Queens' College was built to a simple design with hall, kitchens, library, chapel and chambers arranged around a square courtyard. The second court contains the President's Lodge (pictured), which was extended into a beautiful half-timbered Tudor college building in the early sixteenth century. (Jim Gintner)

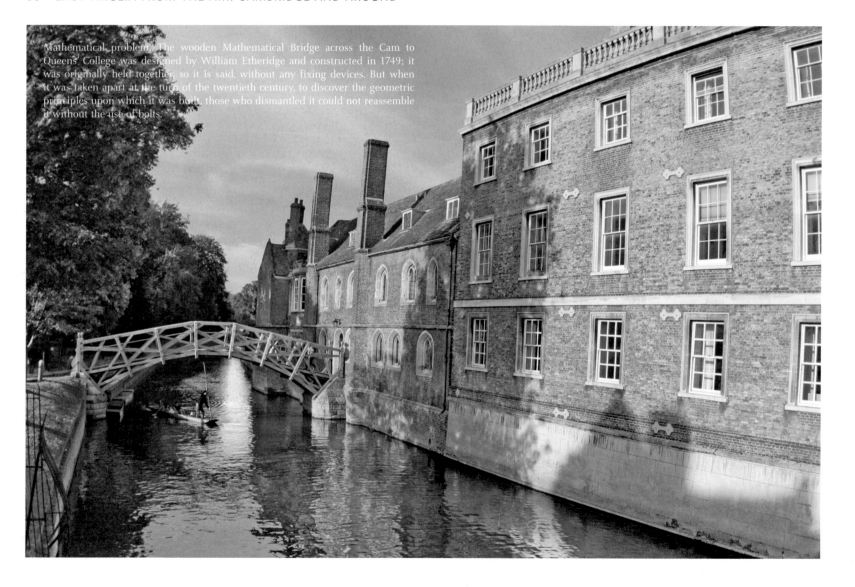

Mathematical problem. The wooden Mathematical Bridge across the Cam to Queens' College was designed by William Etheridge and constructed in 1749; it was originally held together, so it is said, without any fixing devices. But when it was taken apart at the turn of the twentieth century, to discover the geometric principles upon which it was built, those who dismantled it could not reassemble it without the use of bolts.

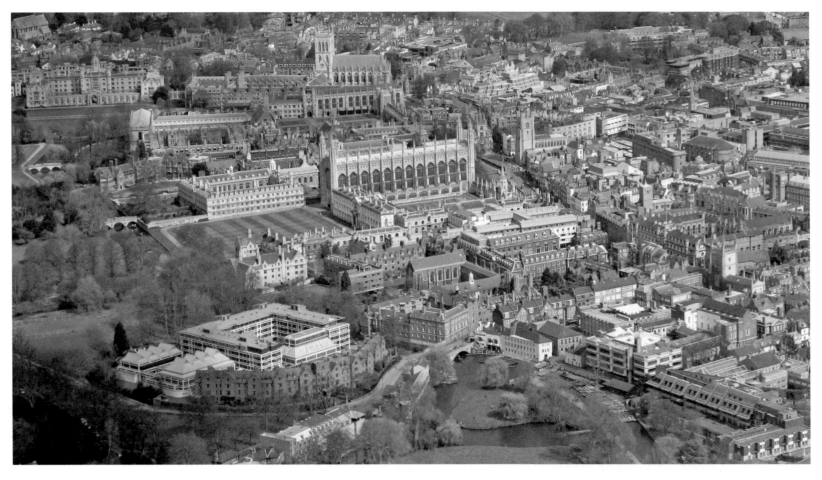

The Mill Pond off Silver Street with the magnificent colleges behind. In the early twelfth century, King Henry I made Cambridge the chief port of the shire. The main commercial area was Quayside (top left) and other quays lined the Cam where the lawns of King's, Trinity and St John's are now. In the fifteenth and sixteenth centuries nearly all of these quays disappeared and trading was concentrated at each end of the Backs, at Quayside and the Mill Pool. For over 900 years Cambridge was a centre of milling, the three main corn mills at the Mill Pool and Newnham Pool being powered by river water. The Bishop's Mill and King's Mill on the site of the present-day weir were combined and converted to steam power in the mid-nineteenth century. In 1928 these mills were demolished. The Mill public house is on the corner of Mill Lane to the left of the row of punts.

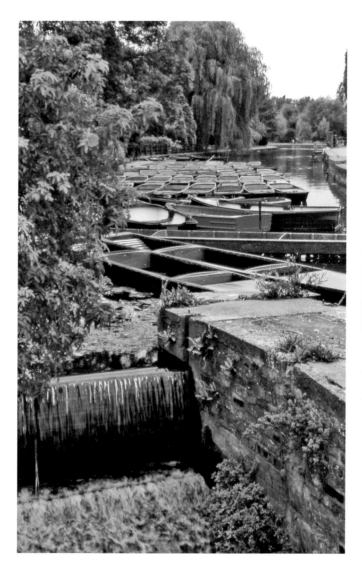

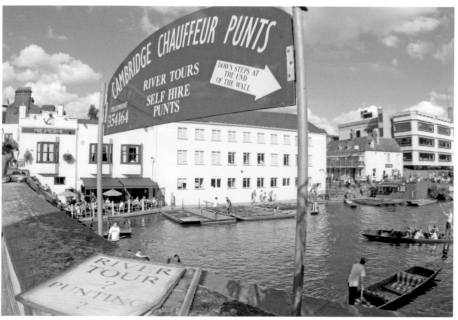

Above: As advertised in the brochure: punting on the river by The Anchor.

Left: The weir on Mill Pond looking towards Coe Fen and Sheep's Green.

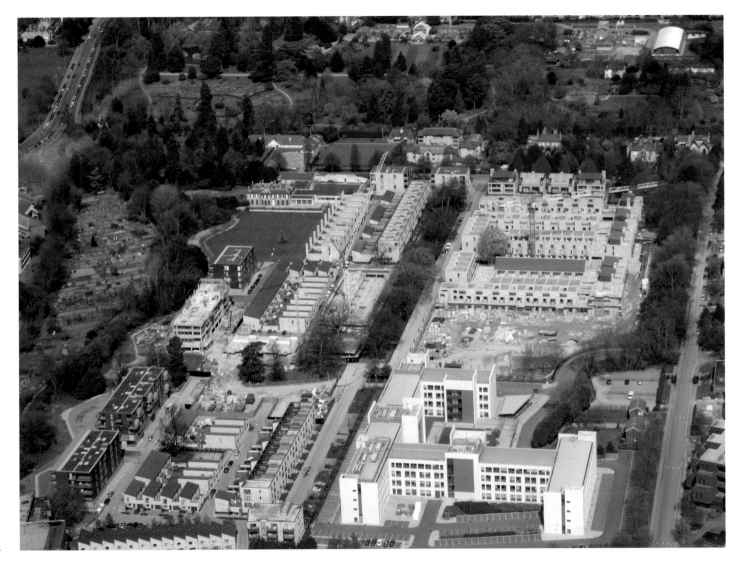

Flats and fields.

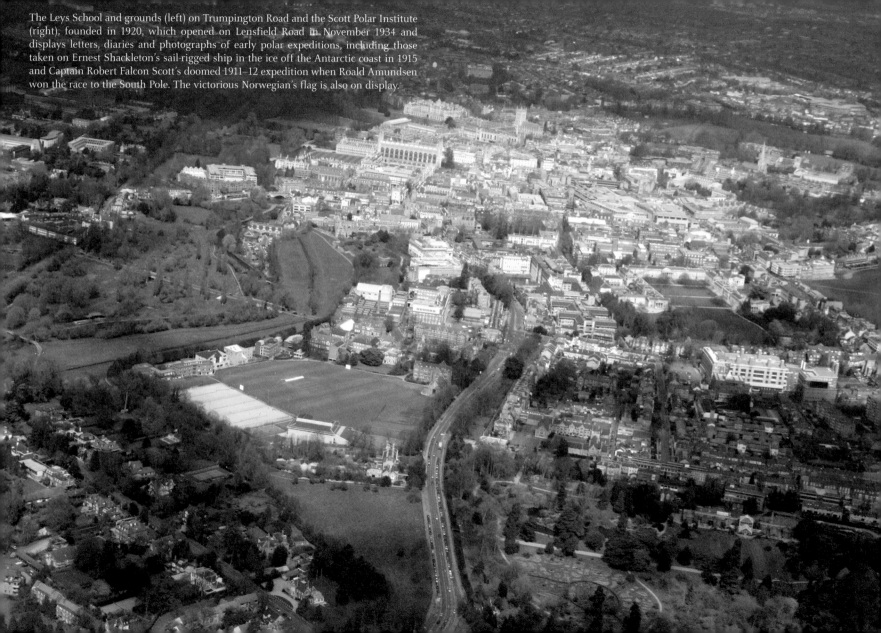

The Leys School and grounds (left) on Trumpington Road and the Scott Polar Institute (right), founded in 1920, which opened on Lensfield Road in November 1934 and displays letters, diaries and photographs of early polar expeditions, including those taken on Ernest Shackleton's sail-rigged ship in the ice off the Antarctic coast in 1915 and Captain Robert Falcon Scott's doomed 1911–12 expedition when Roald Amundsen won the race to the South Pole. The victorious Norwegian's flag is also on display.

Right: Looking towards the Scott Institute, Parker's Piece and the colleges beyond.

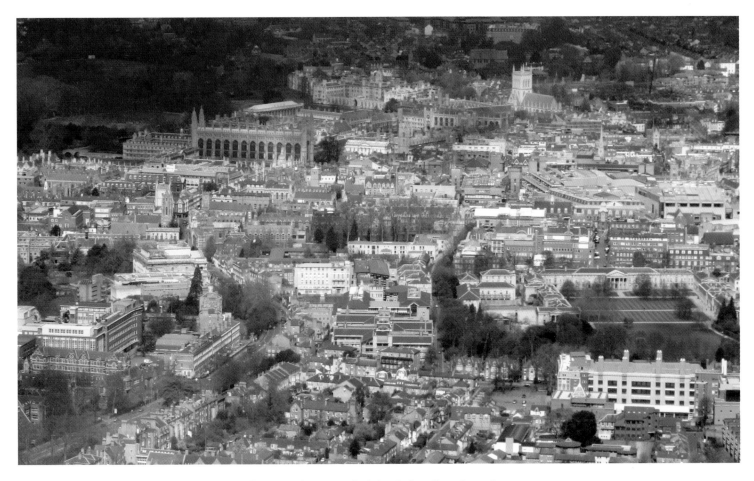

Above: The Department of Chemistry and Scott Polar Research Institute (right) with the colleges beyond.

Opposite: The Scott Polar Institute.

Trumpington Street has particularly deep gutters lining the road that were installed in the seventeenth century in an attempt to improve the city's water supply. The modern Richardson candles have replaced the street lights. On emerging into Trumpington Street the tower diagonally to the right is the Pitt Building, designed around 1830 and named after British Prime Minister William Pitt the Younger (1759–1806), who studied at Pembroke. The Pitt Building is home to the 400-year-old Cambridge University Press, the longest-established publishing house in the world. The University Department of Applied Mathematics and Theoretical Physics is behind the Pitt building. Professor Stephen Hawking, author of A *Brief History of Time*, has his office there.

The imposing, classically-styled Fitzwilliam Museum or 'The Fitz', as it is familiarly known, on Trumpington Street was founded in 1816 by the bequest of the 7th Viscount Fitzwilliam of Merrion who bequeathed £100,000 and the books and paintings for a museum to house his magnificent collections of works of art and antiquities. It opened in 1848 and its collections include exquisite Ming vases, Egyptian mummies and richly-decorated sarcophagi, as well as Greek and Roman antiquities and works of art, drawings and prints, sculpture, furniture, armour, pottery and glass, oriental art, illuminated manuscripts, coins and medals. Today, free lectures and concerts are regular attractions and the museum café is a favourite meeting place. The Judge Institute of Management Studies building opposite was originally a hospital; Dr John Addenbrooke died in 1719 and bequeathed £4,500 to build it.

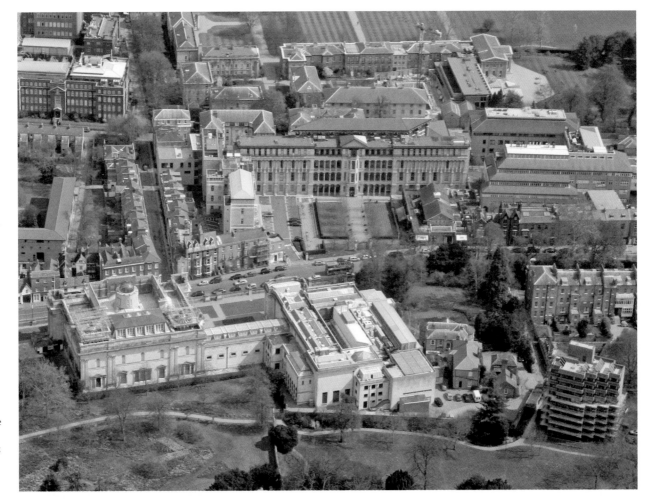

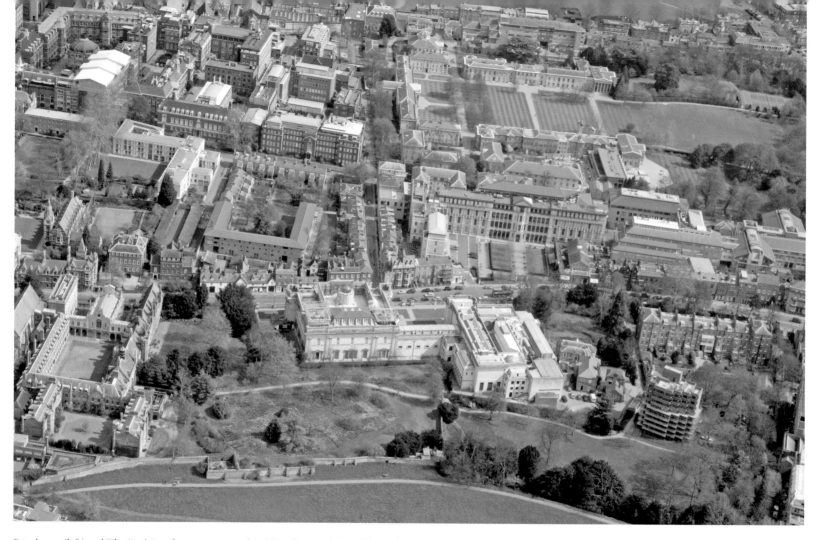

Peterhouse (left) and 'The Fitz'. Peterhouse was started in 1284 after Hugh de Balsham, the Bishop of Ely, decided that he needed somewhere to keep his unruly young scholars under control. Peterhouse (and Corpus) made use of existing churches (St Peter's and St Bene't's) and then built their living quarters nearby. The original thirteenth-century buildings have been altered considerably. Matthew Wren, Christopher Wren's uncle, was master at Peterhouse 1625–34 and he was responsible for the chapel, which combines Perpendicular and classical styles. Former undergraduates include Charles Babbage, inventor of the early mechanical computer, and Sir Frank Whittle, who invented the jet engine.

Pembroke Hall, now Pembroke College, was founded by Marie de Valence, the French Countess of Pembroke in 1347 and is the third-oldest Cambridge College. Former members include William Pitt the Younger and an impressive array of comedy stars, including Peter Cook, Eric Idle, Clive James, Bill Oddie and Tim Brooke-Taylor. Pembroke was the first in Cambridge to have its own college chapel, which was classically designed by Christopher Wren who was commissioned in 1663 by his uncle, Matthew Wren, the Bishop of Ely and a Fellow at Pembroke, later Master of Peterhouse. Matthew Wren had been incarcerated for eighteen years in the Tower of London for being a royalist. It was Wren's first completed building.

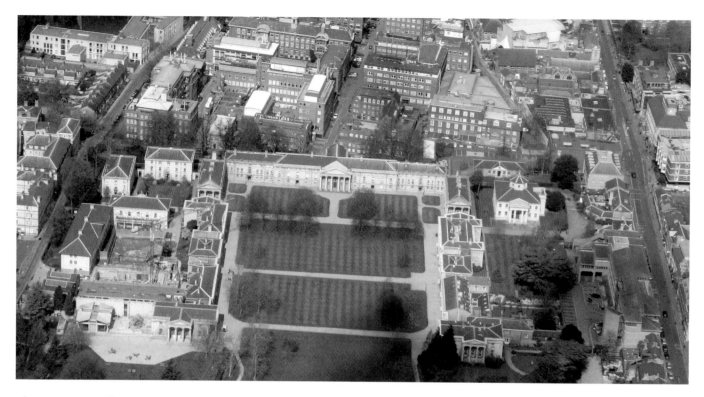

Above: Downing College was founded by the will of Sir George Downing of Gamlingay Park who had been a member of Clare College. Designed by Gothic Revivalist William Wilkins in his earlier, Greek manner, building was commenced in 1807. Downing's foundation charter was granted by George III in 1800 and its neo-classical architecture and spacious campus plan are quite unlike any other college in the university.

Opposite: Downing (centre right) with (behind) the New Museums Site, original home of the Cavendish laboratory and site of the university's physics department until the 1970s. Among other notable events, Lord Rutherford first split the atom here (in 1932), Chadwick discovered the neutron and Crick and Watson uncovered the structure of DNA. The Cambridge computer laboratory has its home here. The New Museums Site is now occupied by Sedgwick Museum of Sciences and Archeology and Anthropology Museum. Fenners Cricket Ground (right) is the university cricket ground where the local non-university clubs play and where Jack Hobbs developed his skills before gaining fame in national and international cricket. Bottom left are Peterhouse and Pembroke Colleges and the Fitz (bottom right).

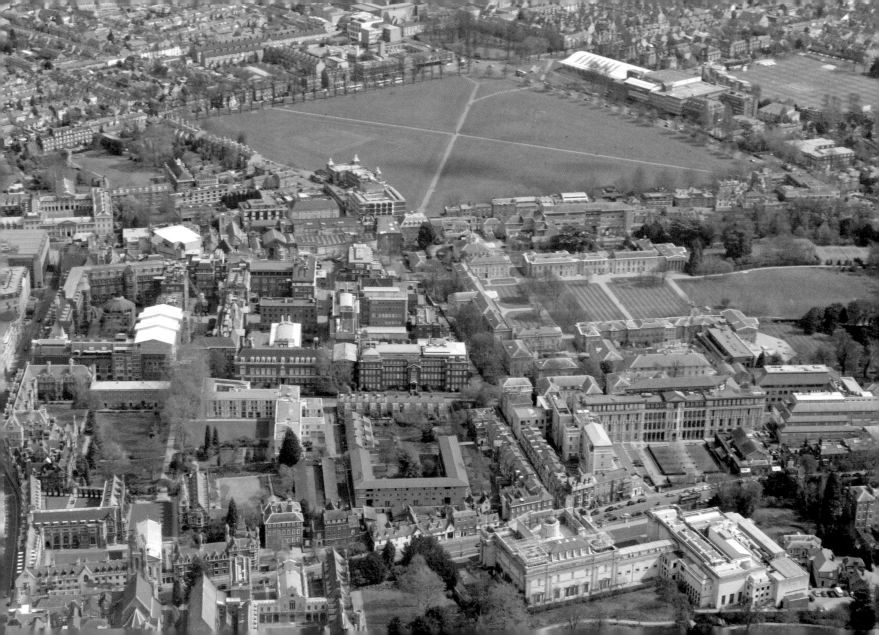

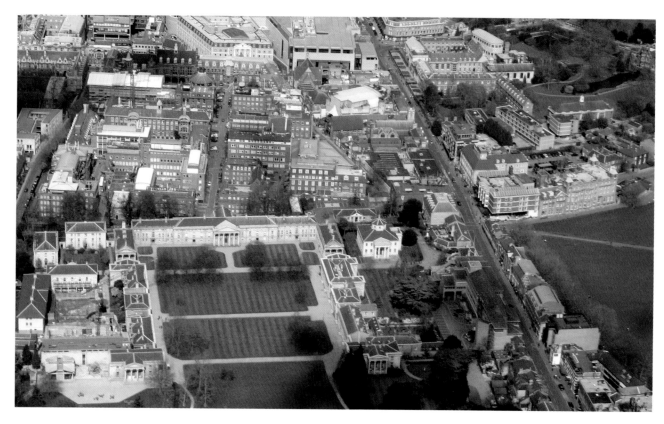

Above: Downing College flanked by Regent Street (right) with Emmanuel College (centre of the picture). Emma's beautiful gardens include the original monks' fishpond and a selection of unusual trees and shrubs. Former members include Graham Chapman, Griff Rhys Jones, F. R. Leavis and Sir Fred Hoyle. Top right is Christ's and the bus station. Right is Parker's Piece, named after Edward Parker a cook to whom it had been leased by Trinity in 1587. It was obtained by the town in 1613. Far right is Hobbs Pavilion on Park Terrace.

Above right: Hobbs Pavilion, which has a batsman wind vane, honours Cambridge's sporting son and is now a restaurant. Born in Cambridge in 1882, Sir John Berry 'Jack' Hobbs was undoubtedly the world's greatest batsman of his time. Between 1905 and 1934 he played in sixty-one test matches and scored a record 61,237 runs. Perhaps his greatest innings at the Oval was against Australia in 1926 when he made a century to help return the Ashes to England.

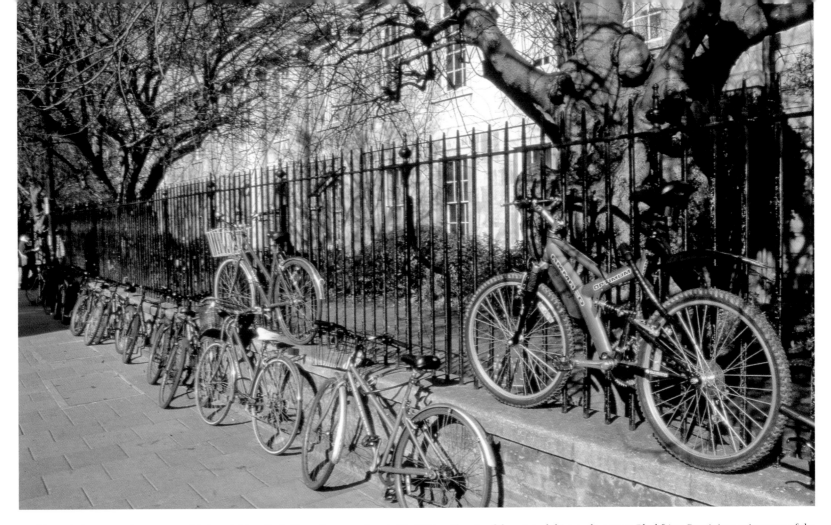

Double parked at Emma (as Emmanuel is invariably called). The college was founded in 1584 on the site of the original thirteenth-century Blackfriars Dominican priory, one of the monasteries dissolved by Henry VIII. The chapel, with its triangular pediment and Corinthian columns, was designed by Christopher Wren in about 1668. Many Emmanuel men sailed for New England including one John Harvard, who died of consumption in Massachusetts in 1638 leaving half his estate and 320 books to found America's first university, which bears his name. That settlement's first pastor (Thomas Shepherd) was also an Emmanuel man and in his honour the town was subsequently renamed Cambridge. About seventy of the colony's founders had been educated there.

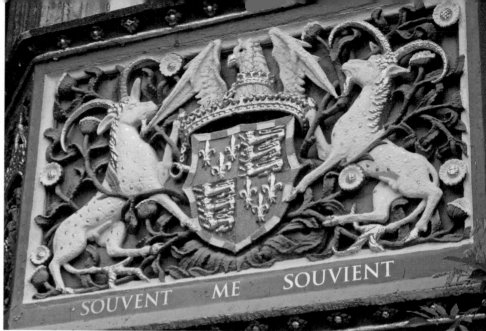

Above: Lady Margaret Beaufort (nicknamed the Lady of Christ's), Henry VII's mother, founded Christ's College in 1505 and she also founded St John's. Lady Margaret was a child bride at seven and she was married for the second time in 1456, to Edmund Tudor when she was just twelve years old. She gave birth to her only child – Henry – the future king, at age thirteen. Henry VII died in 1509. The Beaufort coat of arms is emblazoned over the Master's Lodge in the First Court. The arms show two mythological beasts called yules, holding the royal crest and the crown. The portcullis and red rose represent the Tudor family. The marguerite daisies are a pun on Margaret's name.

Left: Christ's.

Opposite: Christ's (bottom left) and St Johns (top).

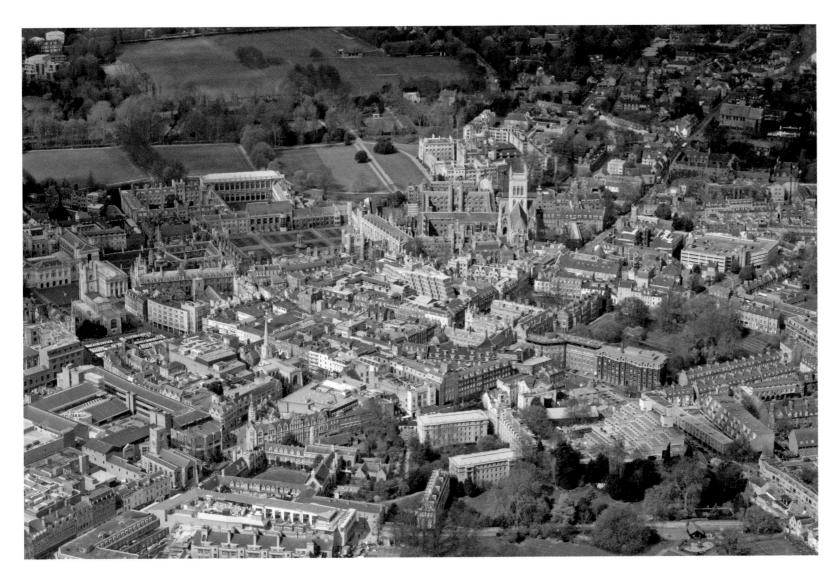

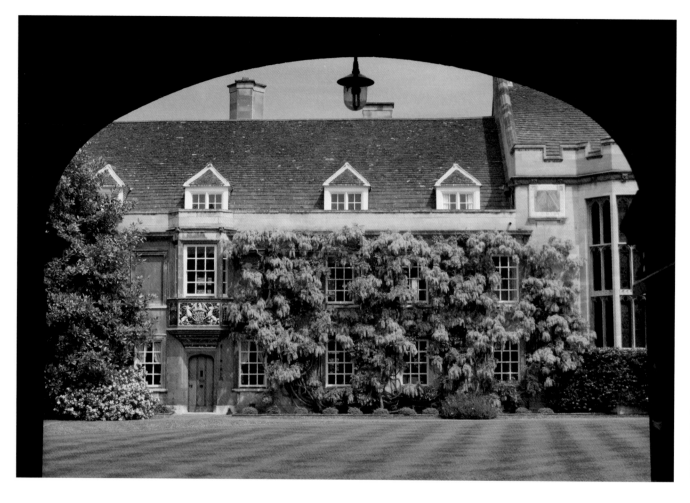

Christ's in May. In the college gardens stands a mulberry tree under which the poet Milton is said to have written 'Lycidas'. (Jim Gintner)

A red bus passes Christ's heading towards Foster's Bank (centre) with Sidney Sussex College further along Sidney Street. One of the smaller colleges and once the Greyfriars Franciscan Friary, Sidney was founded in 1595 by Lady Sidney, Countess of Sussex, at the bequest of Francis Sidney the third Earl of Sussex. Oliver Cromwell entered the college as a fellow commoner in 1616, two days before his seventeenth birthday. He left in 1617 without taking a degree, later becoming MP for Cambridge, and during the Civil War he made the town his headquarters for the Eastern Association. Cromwell's skull is buried underneath its chapel. As the most frequent winners of *University Challenge*, Sidney defeated a team from Harvard in the only international edition of *College Bowl*. John Conway, a Fellow of Sidney Sussex at the time, invented the 'Game of Life'.

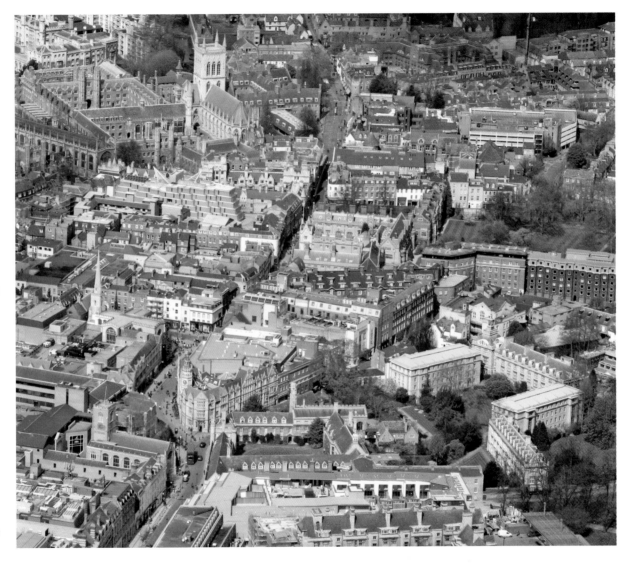

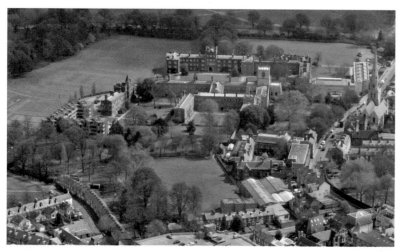

Left: Jesus College, once the Priory of St Radegund a twelfth-century convent, was founded by John Alcock, Bishop of Ely, in 1496. James I visited the college and was so impressed by its tranquil surroundings that he said, given the choice, that he would 'pray at King's, dine at Trinity and study and sleep at Jesus'. The college features spacious grounds and a beautiful sixteenth-century Cloister Court. Since 1955 a new residential block at the back of the college, a new library to the south and other new accommodation to provide rooms on site for as many students as possible have been added. Former members include Thomas Cranmer. Samuel Taylor Coleridge, Alistair Cooke and HRH Prince Edward.

Below left: Foster's Bank.

Below: Orchard Street.

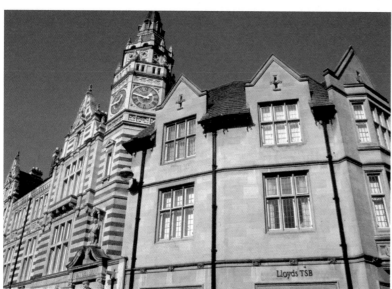

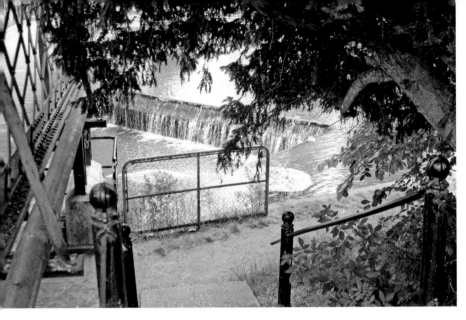

Above: The Jesus Lock footbridge was built in 1892.

Right: Jesus Lock is the limit of navigation on the River Cam for powered craft.

Below: Barges at Jesus Lock.

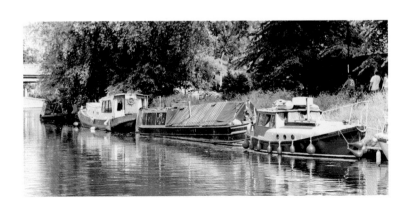

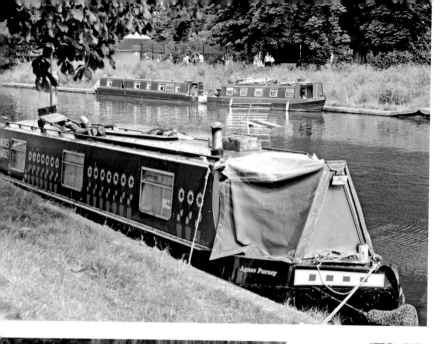

Agnes Purcey. Cambridge has been an important trading centre since the early twelfth century. Fish, eels and sedge (a thick grass for thatching) from the Fens to the North and wheat and barley from the rich arable land to the south were transported in and out of Cambridge by boat. Many earned their living from the river trade, either as merchants or as boatmen plying their barges up and down the Cam.

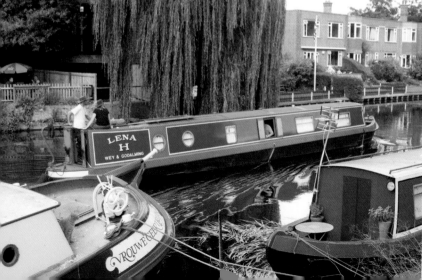

The *Lena H* passes by.

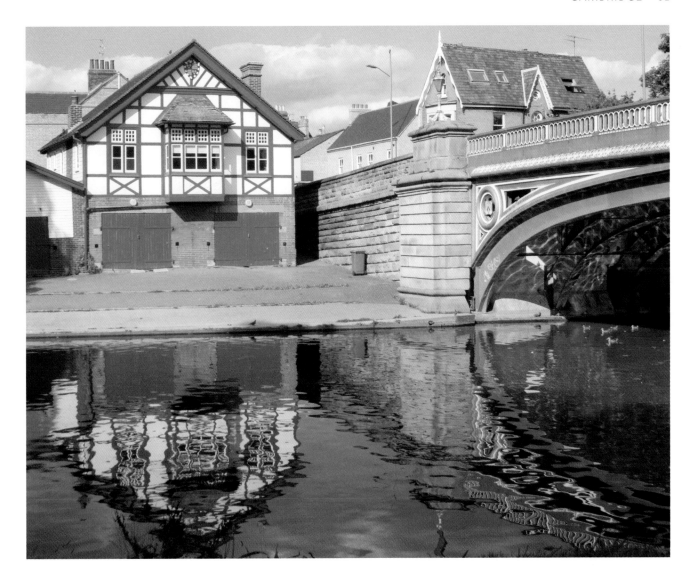

Elizabeth Way Bridge from
Jesus Green.

Above left: Magdalene College, once Buckingham College, a hostel for student Benedictine monks, was refounded in 1542 by Thomas Lord Adley. The best known Master of Magdalene College is A. C. Benson, who wrote 'Land of Hope and Glory'. Samuel Pepys studied here between 1650 and 1653 and on his death in 1703 his priceless collection of 3,000 books, including the original manuscript volumes of his famous diaries, came here. The Pepys Library collection (open to the public) is still stored in the original bookcases. Sited far enough from the town centre to avoid its inmates falling prey to its temptations, it was the last male college to admit women (in 1988). Former members include Sir Michael Redgrave and C. S. Lewis.

Above right: Magdalene Street Bridge.

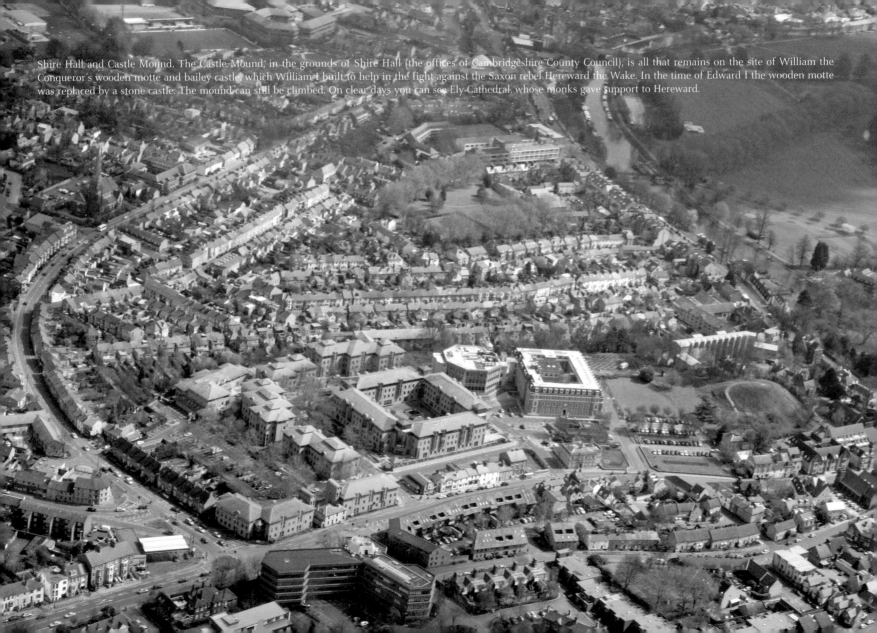

Shire Hall and Castle Mound. The Castle Mound, in the grounds of Shire Hall (the offices of Cambridgeshire County Council), is all that remains on the site of William the Conqueror's wooden motte and bailey castle, which William I built to help in the fight against the Saxon rebel Hereward the Wake. In the time of Edward I the wooden motte was replaced by a stone castle. The mound can still be climbed. On clear days you can see Ely Cathedral, whose monks gave support to Hereward.

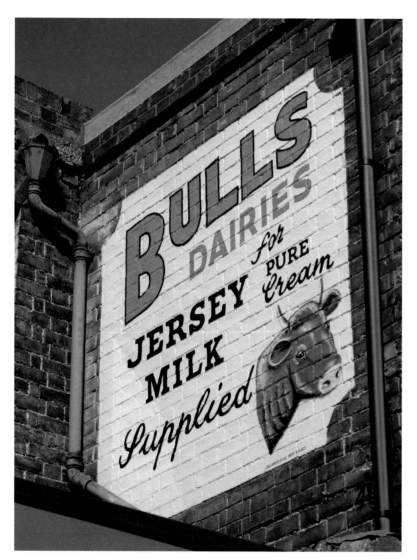

Above: Castle Street.

Left: An advertisement for Bulls Dairies.

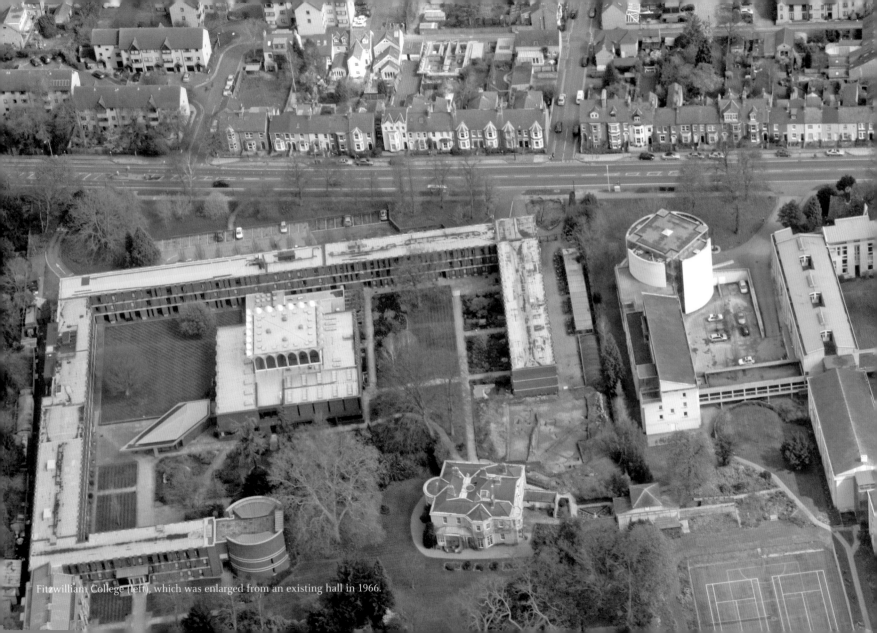

Fitzwilliam College (left), which was enlarged from an existing hall in 1966.

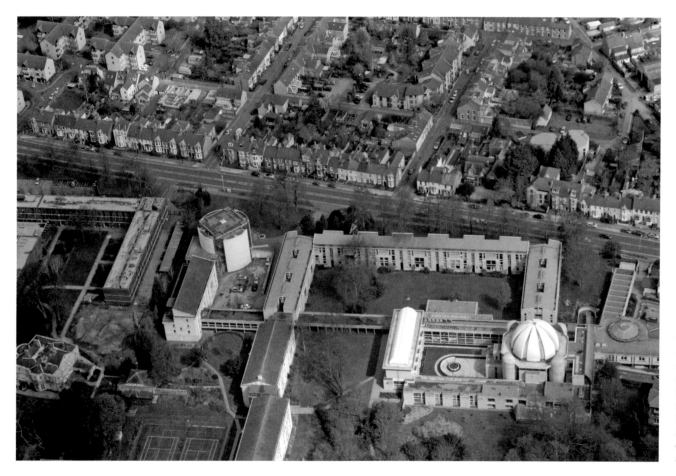

Valparaiso University New Hall (right) on the Huntingdon Road was founded in 1954 for women only. In 1972, three all-male colleges – Churchill (which is mainly for scientists), Clare and King's – all finally admitted women. New Hall is one of only three single-sex colleges that remain, the other two being Newnham and Lucy Cavendish.

Opposite: St John's with St John's Sports Ground and Girton College with the Centre for Mathematical Sciences beyond. Right is Churchill College. Girton started out in Hitchin in 1869 and was moved to Girton three years later – sufficiently far removed from Cambridge and the temptations of its male students. But while these red-brick buildings offered women higher education, it was only fifty years later that women became entitled to receive degrees. On the junction of Madingley Road and Queen's Road are Lucy Cavendish and St Edmund's Colleges.

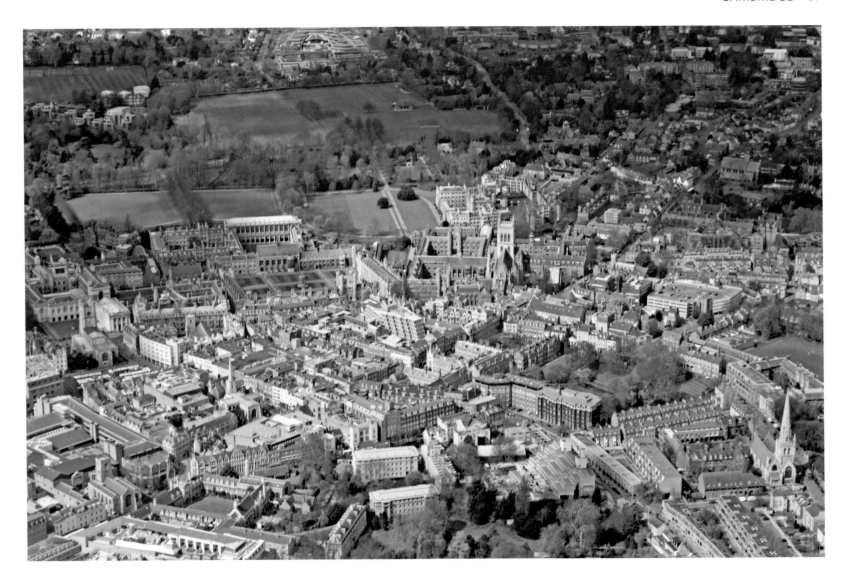

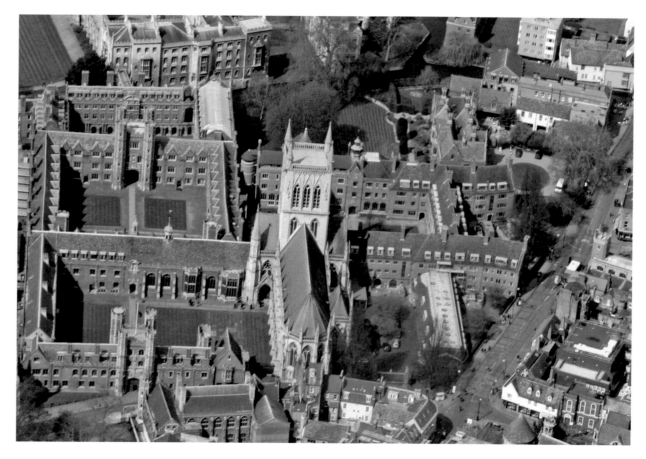

St John's, once the hospital of St John, was founded in 1511. It is the third largest in Cambridge and was one of the wealthiest yet it backed directly onto Kettle's Yard, some of the worst slums in Cambridge. Kettle's Yard today is a beautiful and unique house that contains a distinctive collection of modern art. Next door is a gallery which has a changing exhibition programme of modern and contemporary art. There is a rolling programme of workshops, talks and concerts.

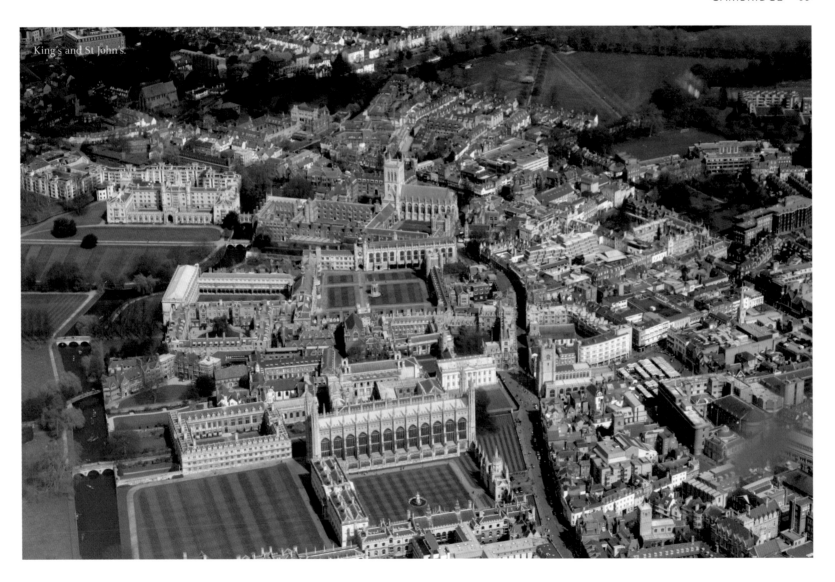

King's and St John's.

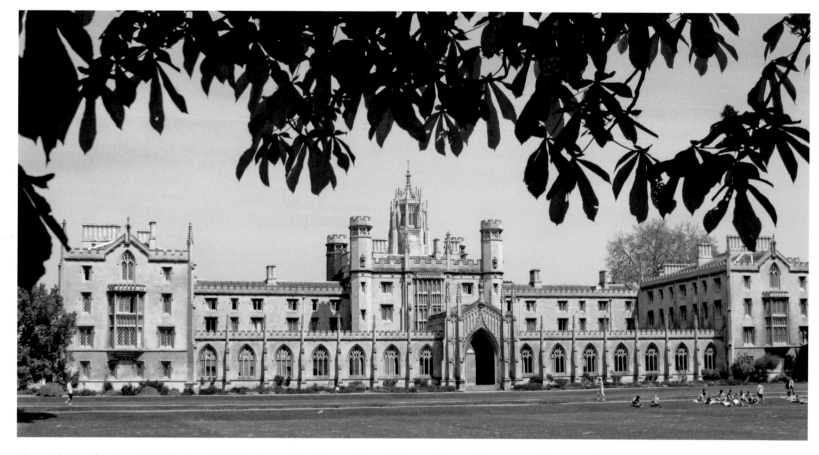

Above: Cloistered existence? St John's so-called New Court with cloister walk at the front and beautifully-manicured lawns overlooking the Backs.

Opposite: St Johns College and the Round Church (centre) with Trinity (left) and Magdalene Street Bridge and College (top right). After the First Court (1510–1520) come the famous Second Court (1598–1602) and Third Court (1669–1673), each younger and smaller than the previous one. Second Court has been described as 'the finest Tudor court in England'.

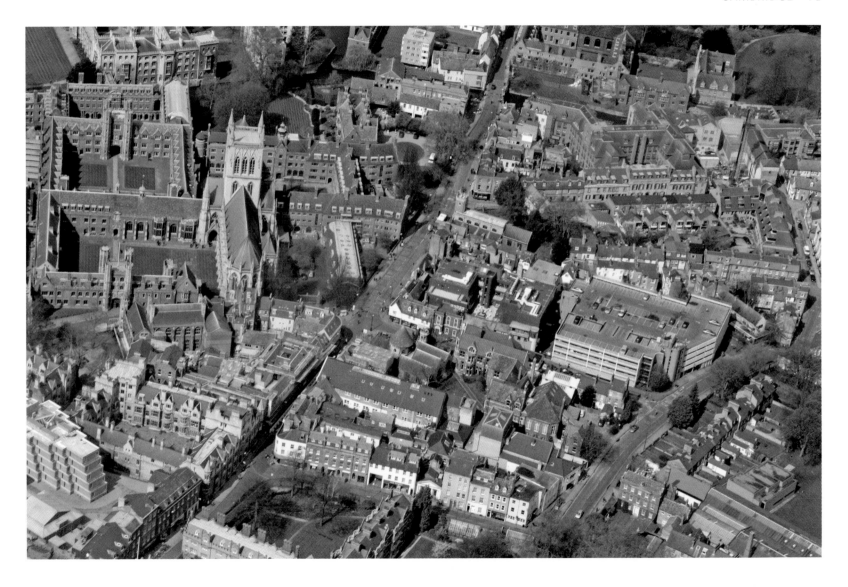

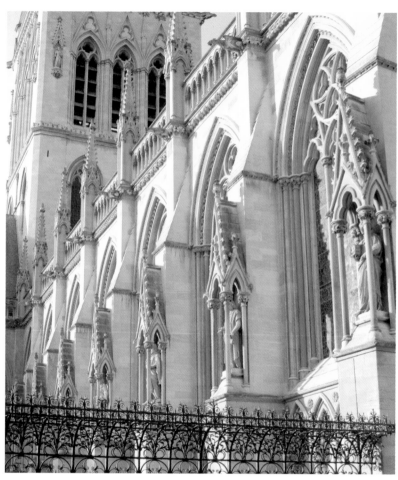

St John's is famous for its imposing chapel, designed by Sir George Gilbert Scott in 1869 and home to one of the best collegiate choirs in the world. It was built between 1863 and 1869.

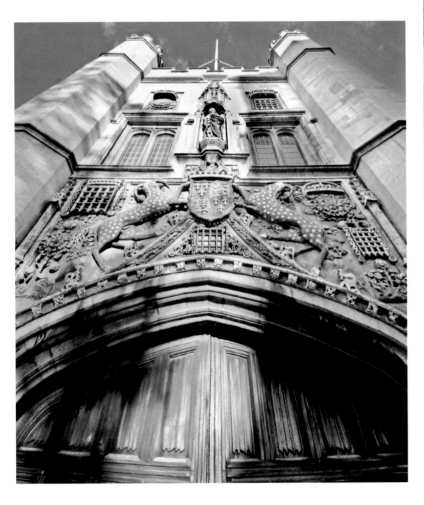

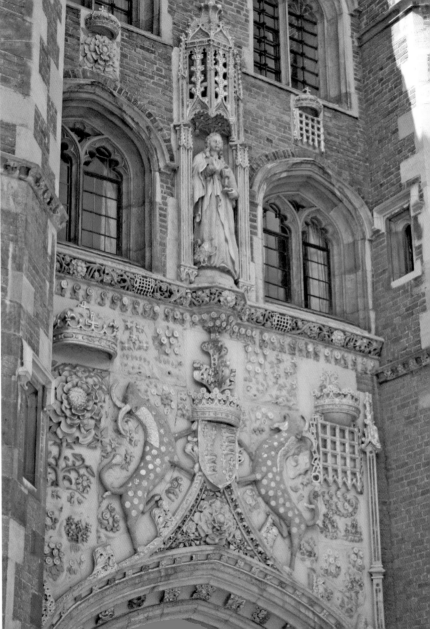

The impressive early-Tudor gateway entrance to First Court at St John's has a glorious display of royal arms, especially those of its founder Lady Margaret Beaufort, whose statue is above.

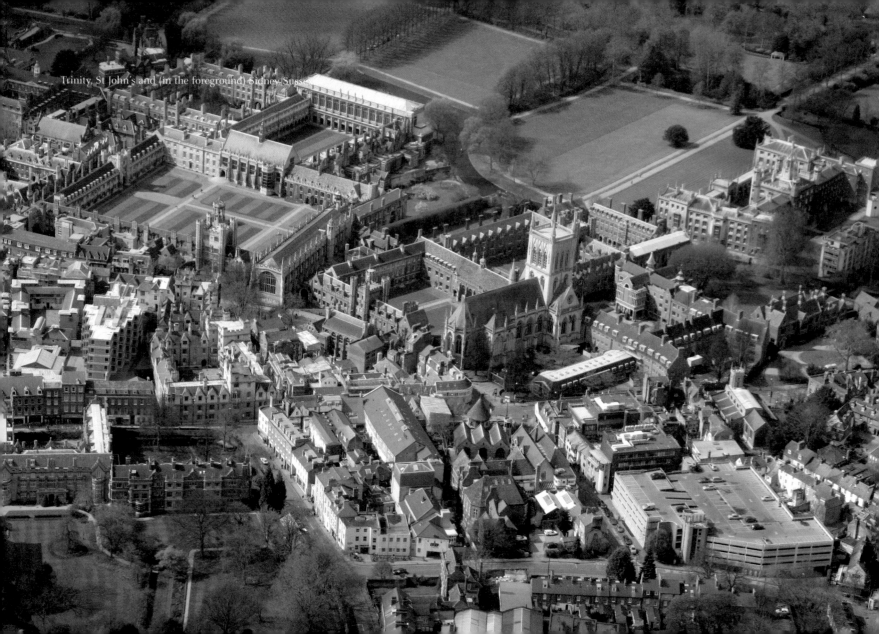
Trinity, St John's and (in the foreground) Sidney Sussex

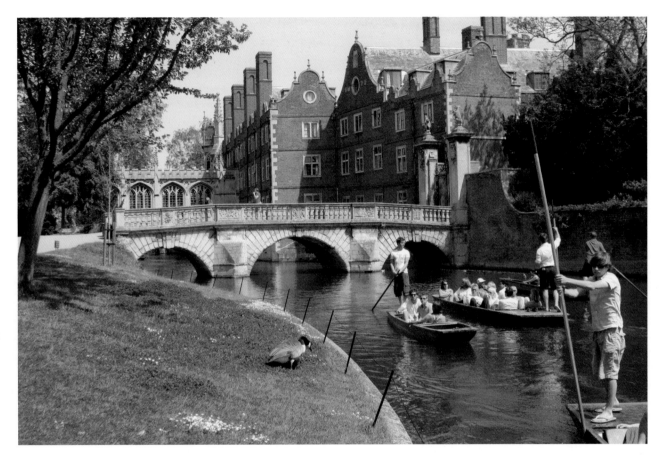

St John's is also famed for Wren Bridge, built by Robert Rumbold 1709–12, which has a balustraded parapet and heraldic beasts on display and is also known as Kitchen Bridge because the Master and Fellows of St John's defied the architect and had it put at the end of the lane leading to the college kitchens. Behind the Wren Bridge can be seen the neo-Gothic Bridge of Sighs, built in 1831, which joins St John's with New Court (1821–31) on the opposite side of the Cam (left). It borrows the idea of the covered bridge from the one of the same name in Venice. The Cambridge version has barred, unglazed windows.

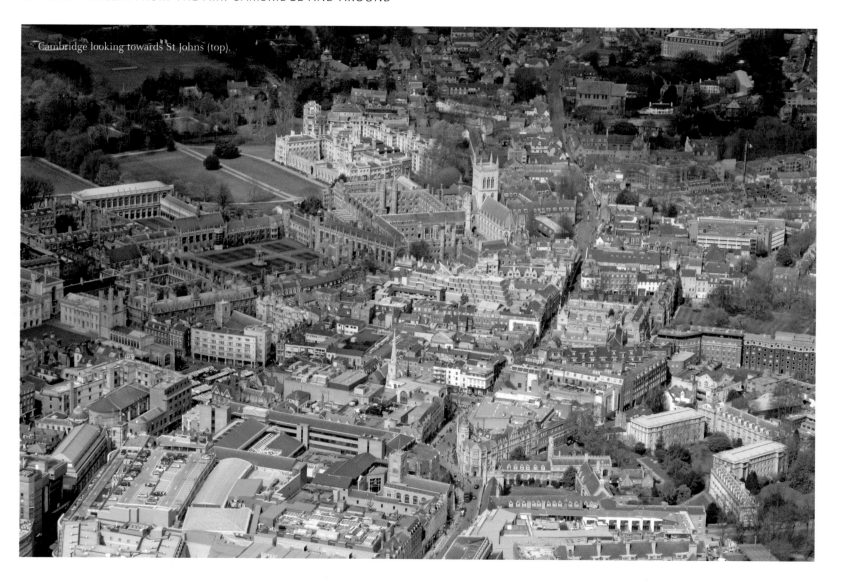

Cambridge looking towards St Johns (top).

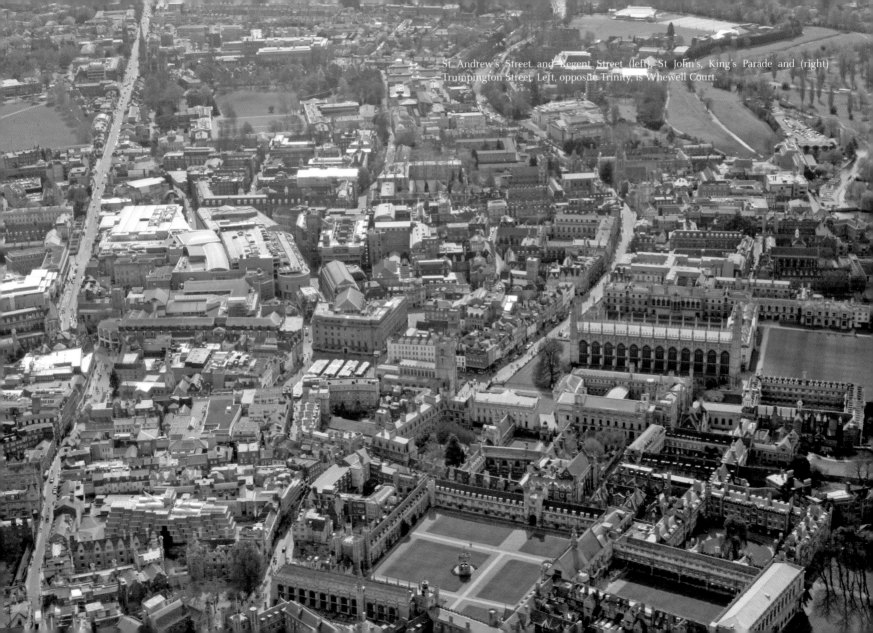

St Andrew's Street and Regent Street (left), St John's, King's Parade and (right) Trumpington Street. Left, opposite Trinity, is Whewell Court.

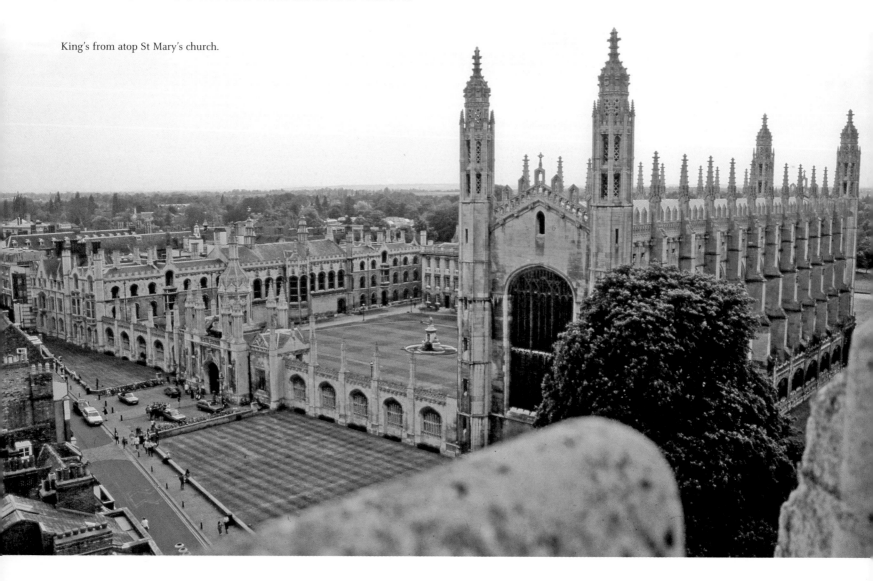

King's from atop St Mary's church.

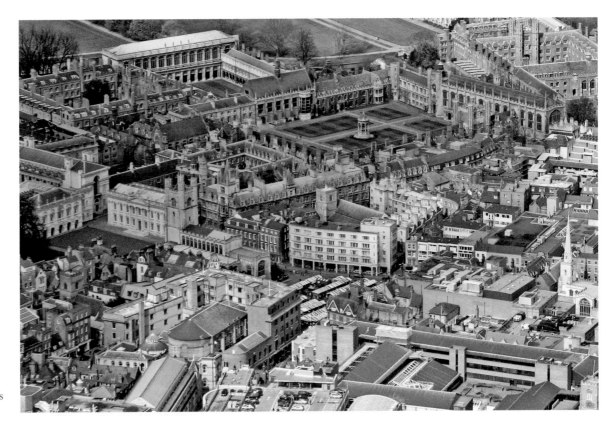

Market Street, Senate House and St Mary's with Gonville and Caius beyond.

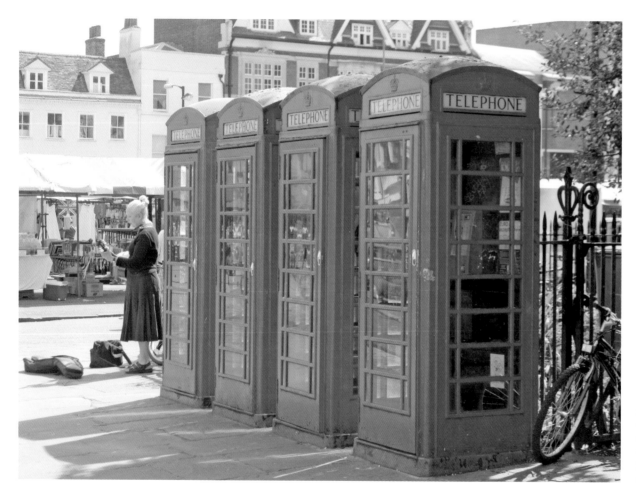

St Mary's Street. The traditional red telephone box was designed by Sir Giles Gilbert Scott, who designed the Cambridge University Library and the Bankside Power Station in London (now the Tate Modern).

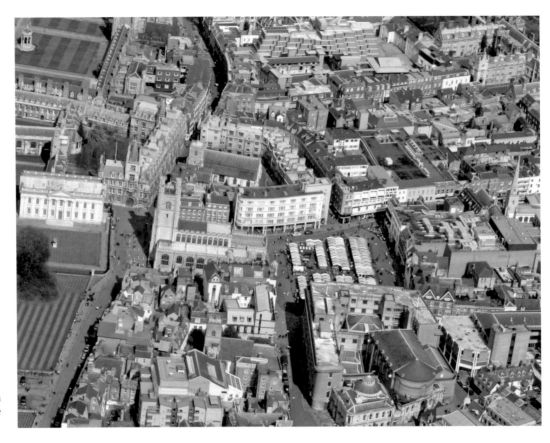

The market and the Guildhall with its neo-Georgian styling, which replaced the earlier one on the south side of the Market Square 1936–37.

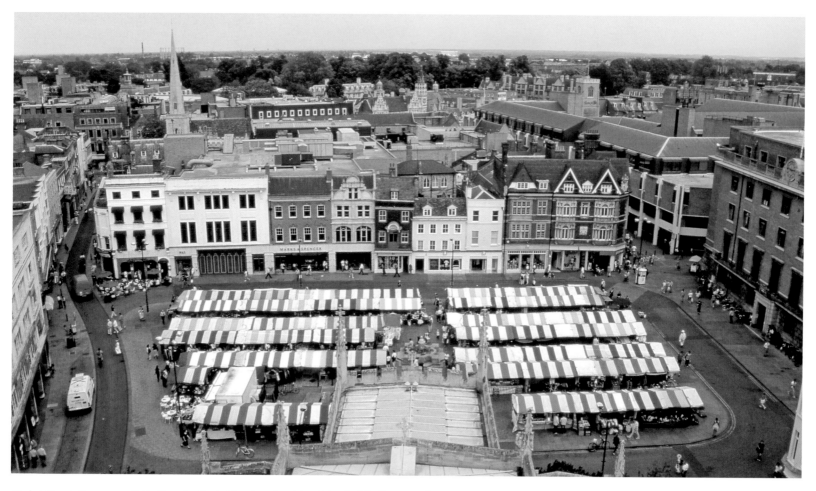

Market Street, the narrow Petty Cury (or Cooks' Row) to the right of the Guildhall running between Market Hill and Sidney Street and the Market, from atop Great St Marys. The colourful and historic open market offers a wide range of produce, goods and services every Monday to Saturday. From superb quality fresh fruit, vegetables, meat and fish to books, clothing, flowers, watches, crafts and even bike repairs – there's something for everyone. A range of refreshments are always available, with stir-fried noodles, hot dogs, great coffee, freshly squeezed juices and hot soups all available in the square!

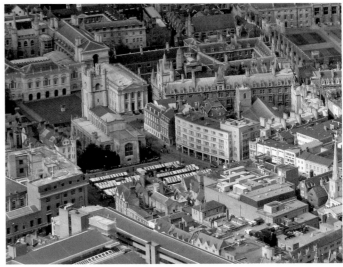

Shopaholics anonymous. Many of this area's old timber-framed buildings were knocked down between the 1800s and 1930s. In 1972 the old Falcon and Lion Yards and housing stretching from Petty Cury to Downing Street were demolished to make way for a new city library, a multi-storey car park and a large pedestrian shopping district between Market Square and St Andrew's Street.

Under the Clock. The Market Square in the heart of the city has a tradition going back to the early Middle Ages, although the present Square replaces houses destroyed by a fire in 1849.

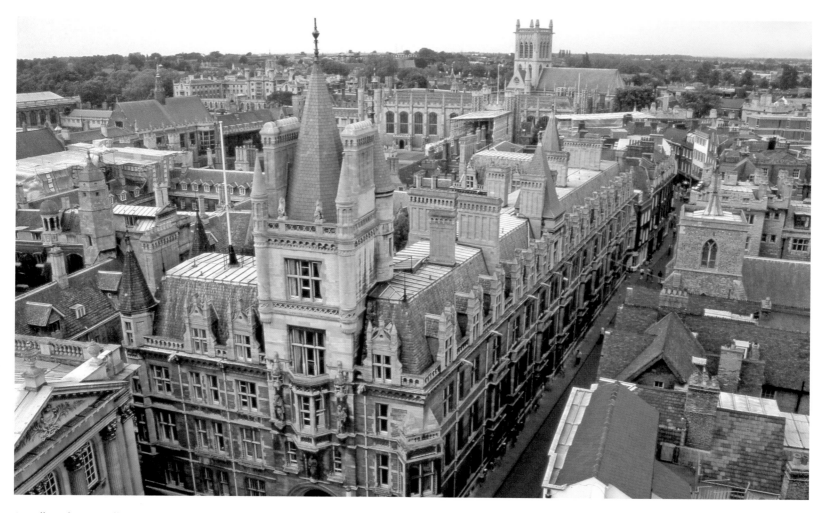

Gonville and Caius College, which has the rare privilege of having been founded twice: by Edmund Gonville in 1348 as Gonville Hall and then again in 1557 by Dr John Caius (pronounced 'keys'), anatomist and physician to Elizabeth I and a fellow of Gonville Hall. He was a Norwich man whose family name was originally Keys; later, it was Latinised, as was the fashion of the day.

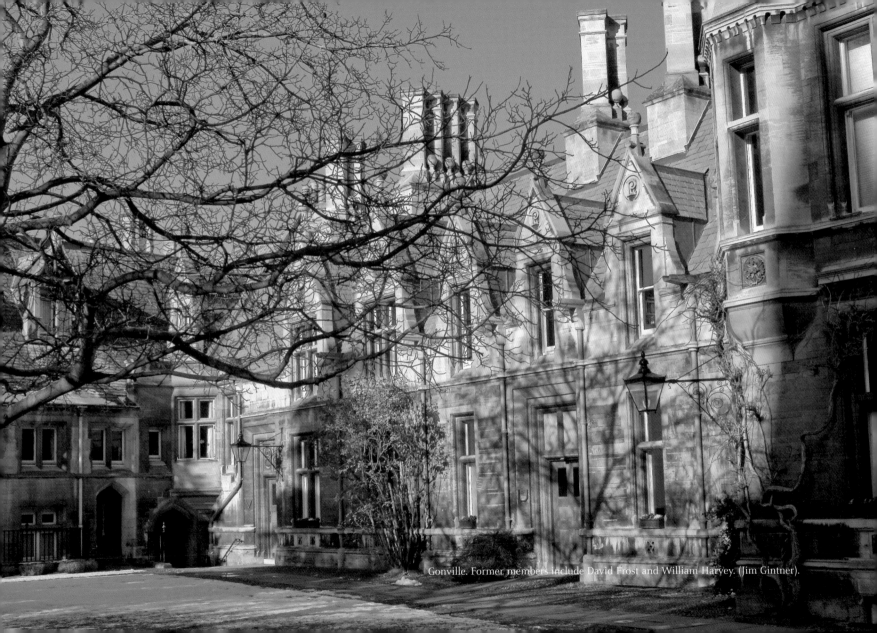

Gonville. Former members include David Frost and William Harvey. (Jim Gintner).

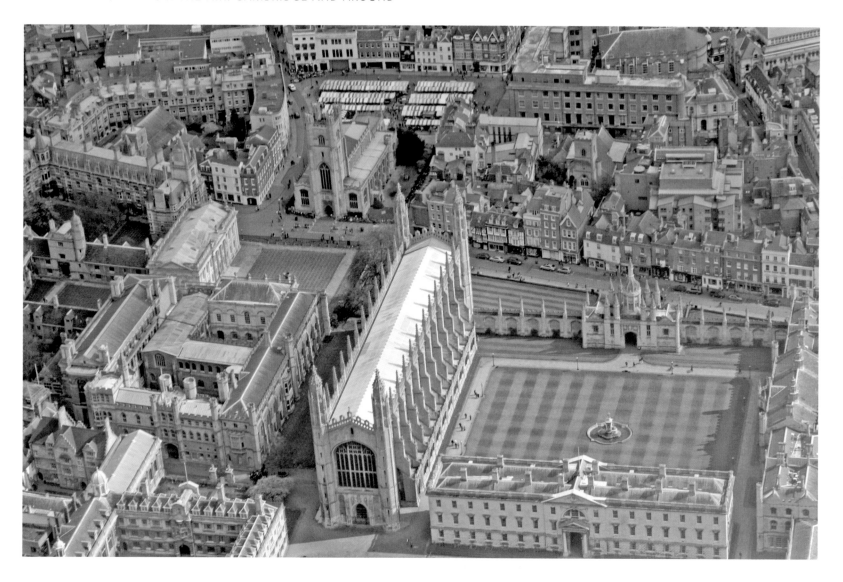

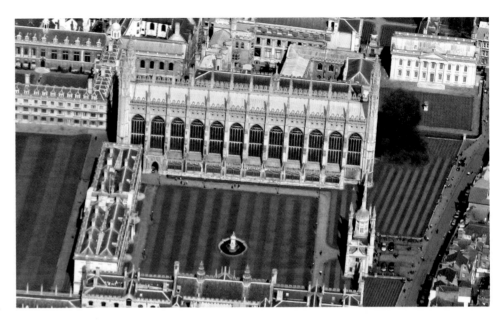

King's and Senate House.

Opposite: Fellows' Building (bottom right), King's Chapel, Senate House and Trinity Hall (left). Gonville and Caius (top left). Great St Mary's church, an impressive piece of Perpendicular architecture dating back to at least 1205, overlooks the Market Place. It soon became the university church, used by both town and gown. In the early sixteenth century, John Fisher rebuilt St Mary's to a more lavish design. In 1535 he was the first of five university chancellors who were executed. Henry VIII donated 100 oaks from a nearby estate for the beautiful beamed roof. Many great clerics have preached here including Latimer, Ridley and Thomas Cranmer, a brilliant scholar who studied at Jesus.

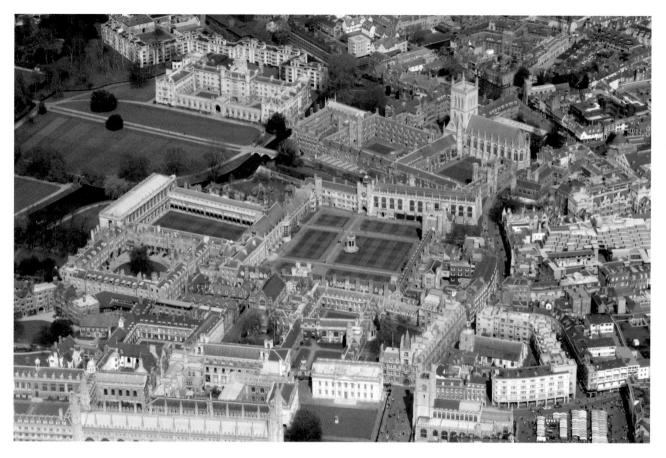

Trinity is the largest of the Cambridge colleges with around 900 students in all. According to some, Lord Byron kept a bear (because dogs were not allowed), which he led around the college on a chain. The north cloister is where Newton is said to have stamped his foot and timed the returning echo to measure the speed of sound for the first time. Sir Isaac Newton's theory of gravity is said to have been inspired by watching an apple fall from a tree. Today, a descendent of the original tree known as 'Newton's Tree' stands just outside the Great Gate by the windows of the rooms between the chapel and gatehouse he occupied in the seventeenth century. Other famous alumni include Vaughan Williams, Bertrand Russell, A. A. Milne, Vladimir Nabokov, Dryden, Ernest Rutherford and HRH Prince Charles (in 1967).

Opposite: Trinity is the only college where the Crown and not the Fellows appoint the Master. The Master of Trinity, Isaac Barrow, a fellow mathematician, asked Christopher Wren to design a magnificent new library, 1676–90, which became the Wren Library (at the foot of the picture). This classical masterpiece has woodcarvings by Grinling Gibbons and a statue of Lord Byron and holds Newton's Principa Mathematics, letters by Byron and many famous manuscripts, including *Winnie the Pooh* and those by Milton, Macaulay, Thackeray and Lord Alfred Tennyson. In 1593, former Master, Thomas Neville designed the Great Court, the largest university quadrangle in Europe. It is an irregular shape made up of a hotchpotch of styles and was finally completed in 1615. Neville added an Elizabethan dining hall and in 1610 Italian craftsmen built the canopied fountain in the centre. It was supplied with water from springs a mile away.

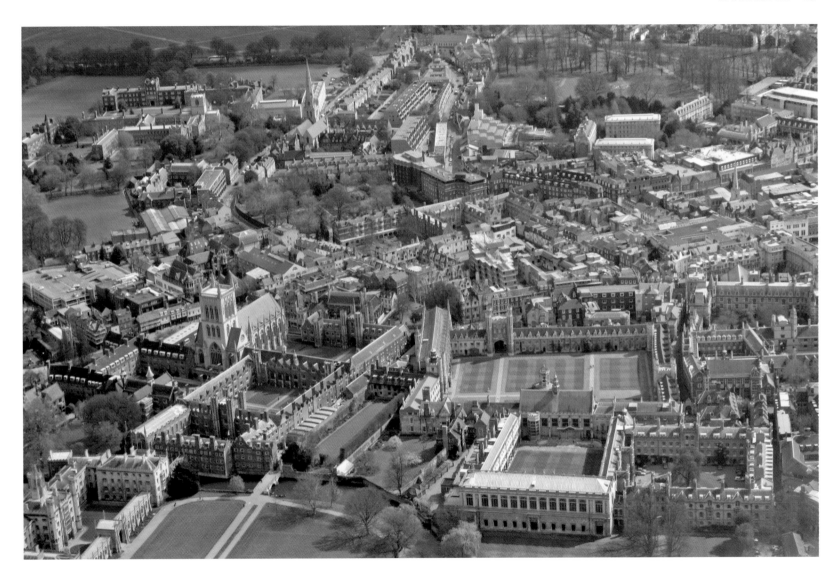

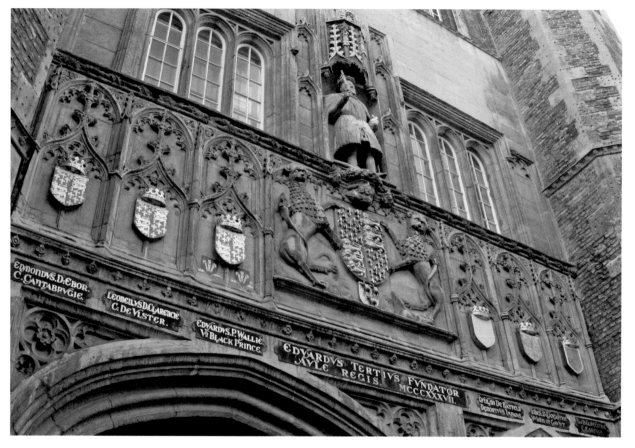

Henry VIII founded Trinity College in 1546, using money and lands from twenty-four dissolved religious establishments and amalgamating two earlier colleges, Michaelhouse and King's Hall. He stands proudly over the Great Gate, originally built as the gatehouse to King's Hall. The king is holding an orb in one hand and what looks like a sceptre in the other. However the 'sceptre' is actually a wooden chair leg! The sceptre was removed as a practical joke and the chair leg has remained there ever since. On the other side of the Great Gate there are statues of King James I, his wife Anne and his son Charles. The oldest part is King Edward's Tower built in the early fifteenth century. Mary Tudor began the chapel in 1554, in memory of her father, Henry. (Jim Gintner)

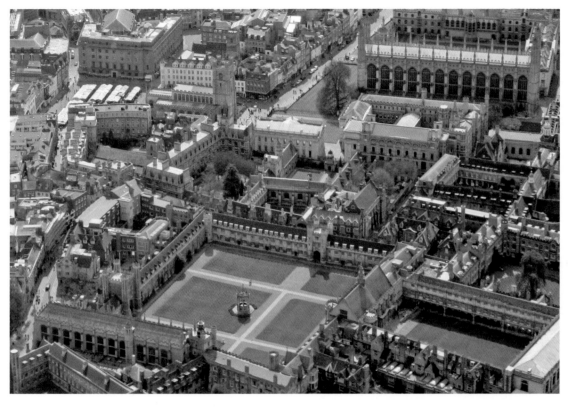

It is customary for undergraduates at Trinity to attempt the Great Court Run every year at noon on the day of the Matriculation Dinner. It involves trying to sprint round the perimeter while the college clock is striking midnight, including the preparatory chimes and the two sets of twelve (the clock strikes each hour twice). The length of time between the start and the finish of the chimes is about forty-three seconds, although this varies according to the state of winding and atmospheric conditions. The distance is 380 yards. In 1927, his final year at Magdalene, Lord Burghley amazed colleagues by sprinting around the Great Court in the time it took the college clock to toll 12 o'clock. Burghley, a hurdler who won Olympic Gold in 1928 and Silver in 1932, is also said to have set another unusual record by racing around the upper promenade deck of the *Queen Mary* in fifty-seven seconds, dressed in everyday clothes. The Great Court Run was featured in 1981 in the Oscar-winning film *Chariots of Fire*, whose character Lord Andrew Lindsay is based upon Burghley and it features the rivalry between Harold Abrahams and Eric Liddell who both won Olympic Gold in 1924. In the film Abrahams accomplishes the same feat as Burghley, who did not allow his name to be used because of the inaccurate historical depiction (there was never a race upon which Abrahams beat Burghley). Incidentally, the run was filmed at Eton and not Trinity. In October 1988 the race was recreated for charity by Steve Cram and Sebastian Coe, who won with a time of 45.52 seconds. On 20 October 2007 Sam Dobin, a second year undergraduate reading economics, ran a time of 42.77 seconds.

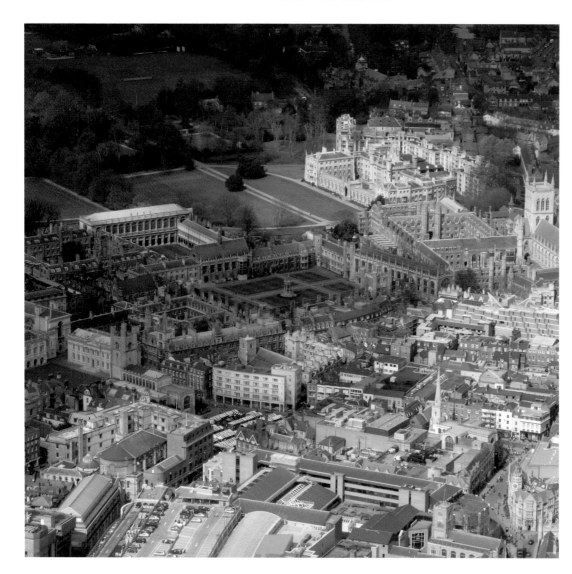

Looking towards Trinity and Trinity Hall.

Opposite: King's Chapel and Clare with Trinity Hall in the foreground. Trinity Hall is not part of Trinity College but a college in its own right, being founded in 1349 by William Bateman, the Bishop of Norwich. For centuries Trinity Hall became the place of excellence for people studying law. It features a striking Elizabethan library and the smallest college chapel in Cambridge. Former members include J. B. Priestley.

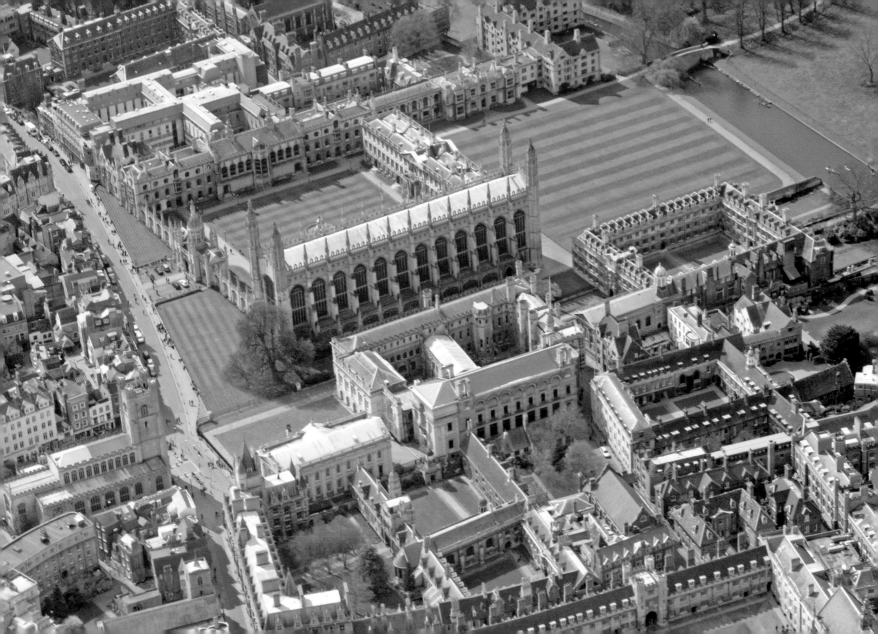

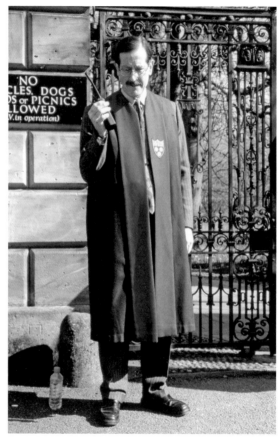

Above: Ringing the changes.

Left: Trinity Hall in spring.

Opposite: King's, Trinity Hall, Senate House and Gonville & Caius, Trinity and St Johns (top). Market and the Guildhall (bottom). Jesus Green (top right).

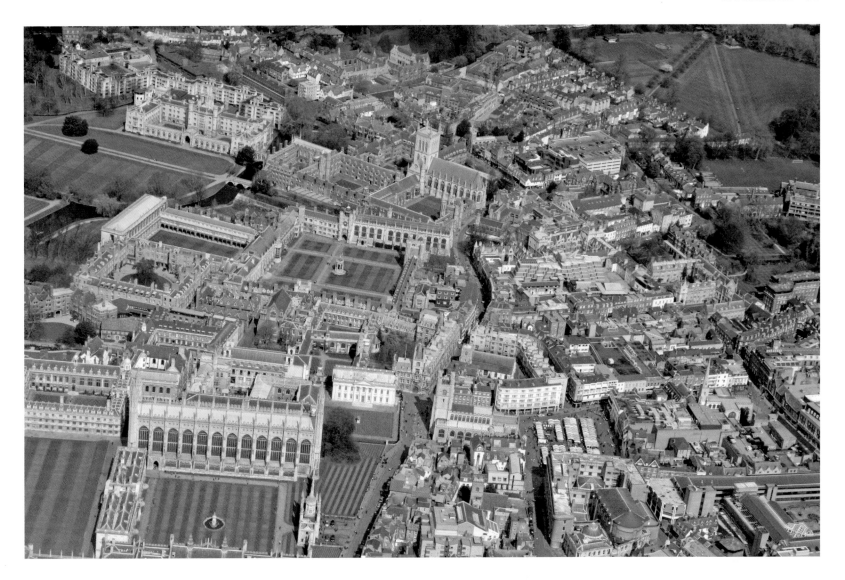

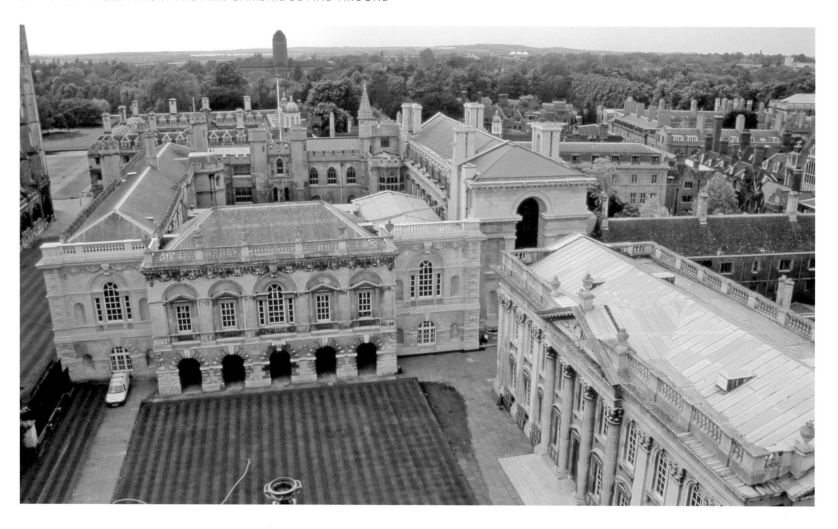

Viewed from Great St Mary's Church, where students received their degrees before the Senate House (right) was built in the early eighteenth century are Trinity Hall and, behind, the University Library on the opposite side of the Cam.

The Cambridge University Press bookshop in Trinity Street, where books have been sold since at least 1581.

Above: Great St Mary's church.

Opposite: King Henry VIII looks down through the awnings on King's Parade.

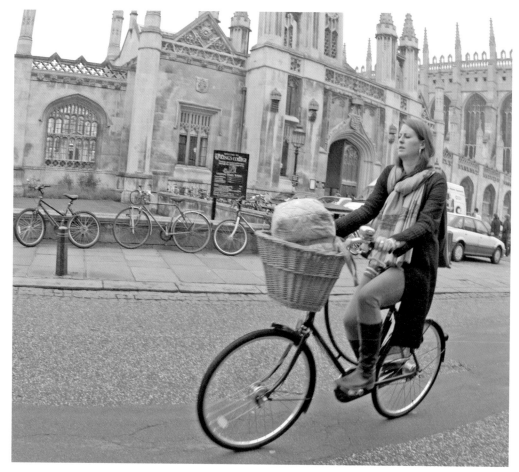

Above left: On King's Parade the beautifully-pinnacled screen and gatehouse, with its ornate spires. It leads into the front court of King's College and was built in 1828 by Gothic Revivalist William Wilkins. Beyond is the chapel, unsurpassed in its magnificence, with the largest and most complete set of ancient windows in the world, breathtaking fan vaulting and glorious stained glass.

Above right: Cycle lain. Bicycles are often the quickest method to get around the congested city.

Above: I can see the joke.

Right: Trick cyclist.

College scarves.

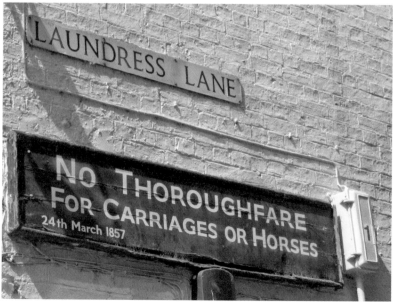

Laundress Lane.

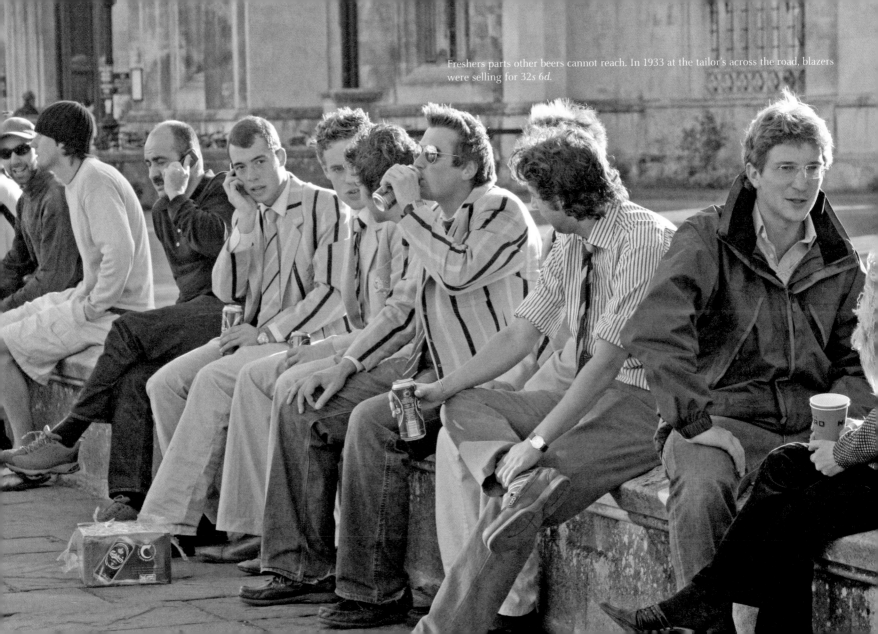

Freshers parts other beers cannot reach. In 1933 at the tailor's across the road, blazers were selling for 32s 6d.

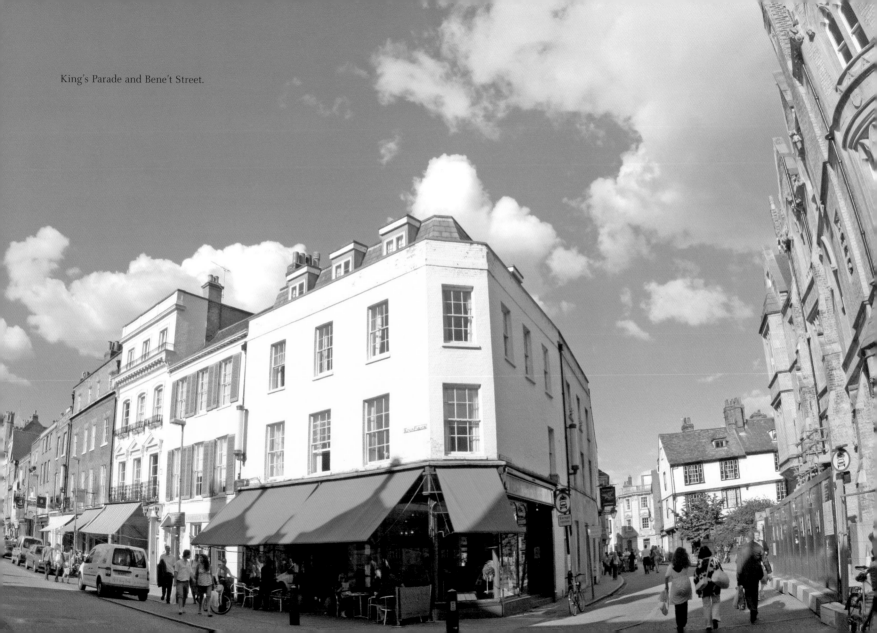

King's Parade and Bene't Street.

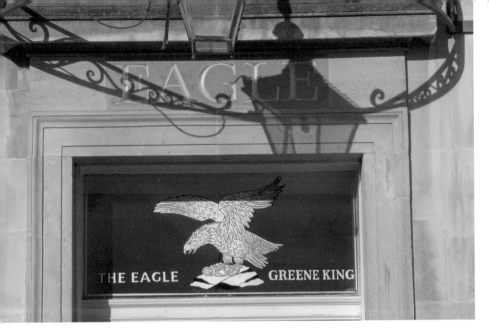

The Eagle in Bene't Street. The site upon which the Eagle stands was bequeathed to Corpus Christi College in 1525. The Eagle & Child, as it was known originally, built up a favourable reputation as a coaching inn but by the late eighteenth century it was demoted to a mere tavern. In the 1820s the Eagle underwent extensive redevelopment and regained its status during the golden age of coaching, as more and more people took to travelling. By 1834 it was possible to board a superior fast coach to London for the sum of 4*s* and to obtain a service to Wells, Oxford, Birmingham and even Manchester for 16 shillings (outside) and 26 shillings (inside). In the eighteenth and nineteenth centuries the Eagle became the headquarters of a political club called The Rutland Club, founded by John Mortlock in 1728 who weaved a web of bribery and corruption that was to hold Cambridge in its grip for almost half a century. With the coming of the railway in 1840, the Eagle once again declined, losing its coaching function. In the early 1850s the inn was divided, the rear becoming a tavern, while the front was used as a hotel until the early 1860s when the building was converted into offices and so remained until 1988. Today, the Eagle once again incorporates the Bene't Street frontage.

St Catharine's.

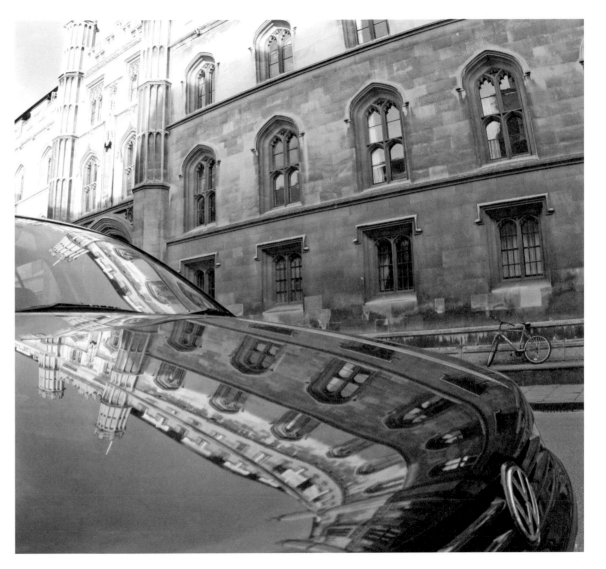

Cambridge blue at Corpus.

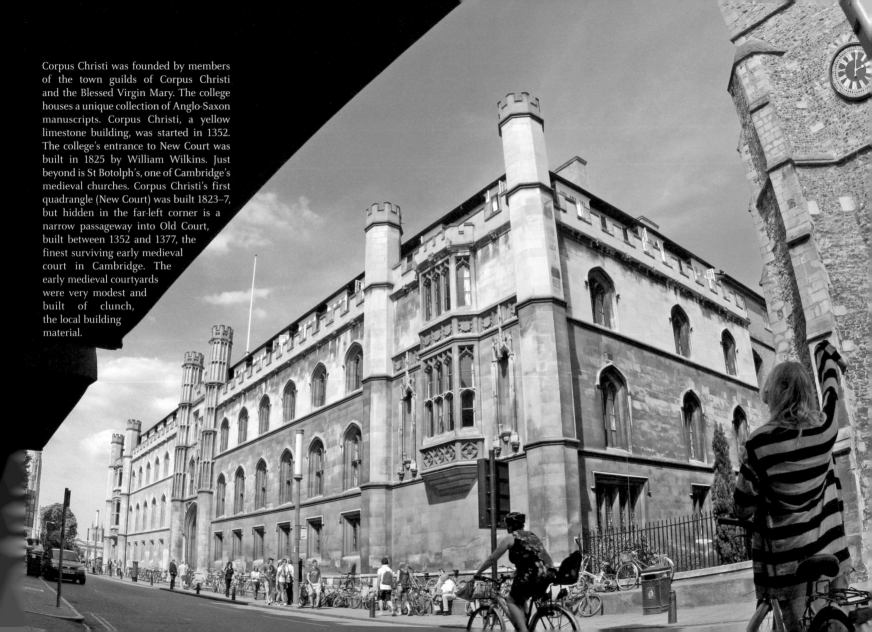

Corpus Christi was founded by members of the town guilds of Corpus Christi and the Blessed Virgin Mary. The college houses a unique collection of Anglo-Saxon manuscripts. Corpus Christi, a yellow limestone building, was started in 1352. The college's entrance to New Court was built in 1825 by William Wilkins. Just beyond is St Botolph's, one of Cambridge's medieval churches. Corpus Christi's first quadrangle (New Court) was built 1823–7, but hidden in the far-left corner is a narrow passageway into Old Court, built between 1352 and 1377, the finest surviving early medieval court in Cambridge. The early medieval courtyards were very modest and built of clunch, the local building material.

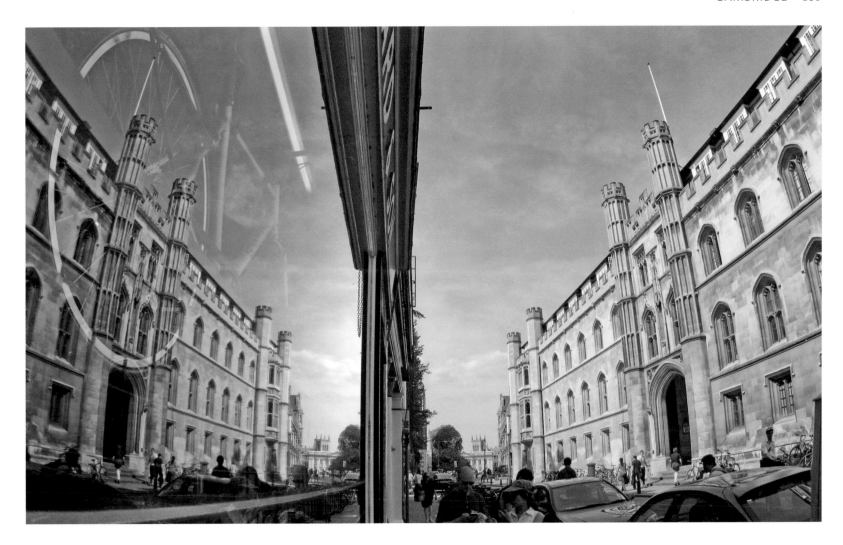

Time for reflection. Famous Corpus Christi members include the dramatist Christopher Marlowe.

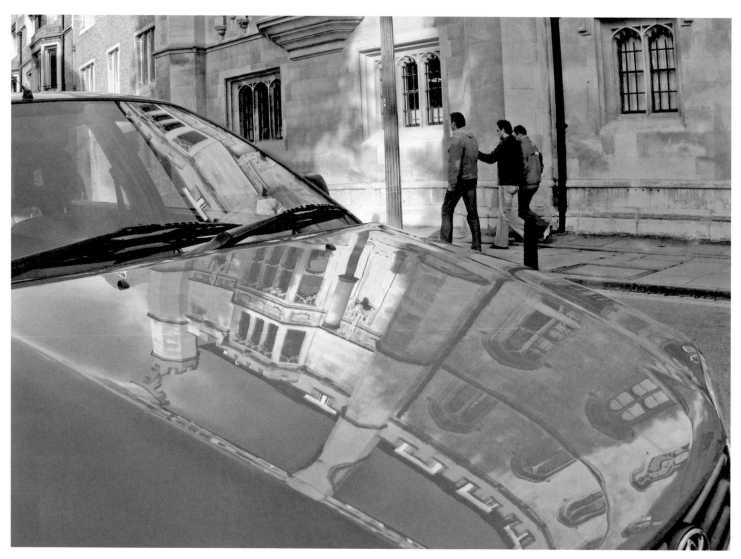

Corpus
delicti.

Above: Silver Street robe makers.

Right: Cycling in Silver Street.

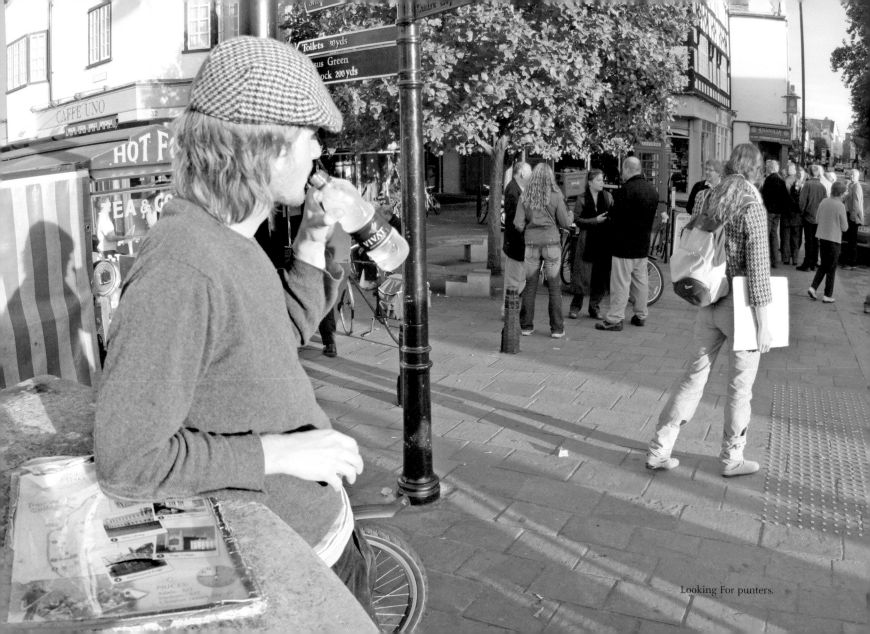

Looking For punters.

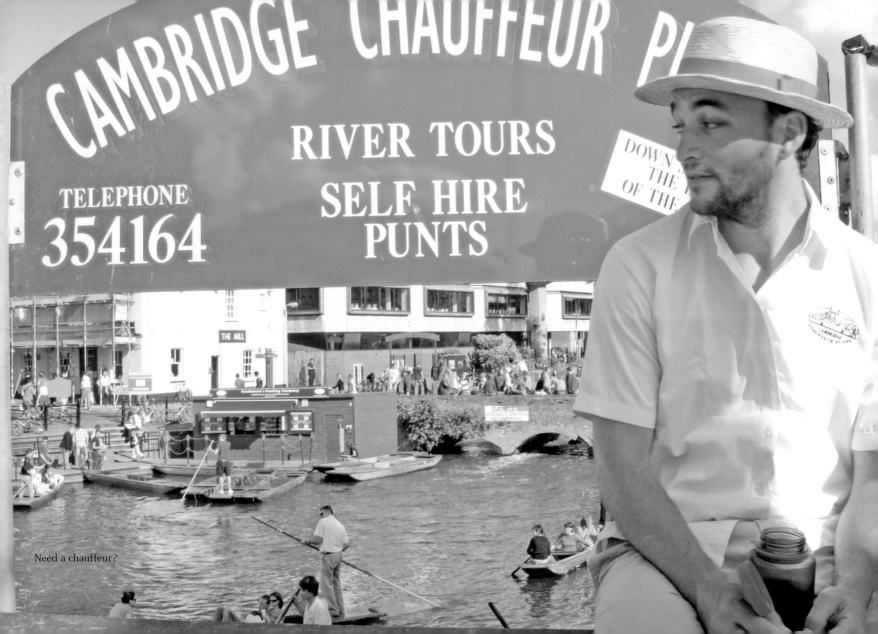

CAMBRIDGE CHAUFFEUR P[

RIVER TOURS
SELF HIRE
PUNTS

TELEPHONE
354164

Need a chauffeur?

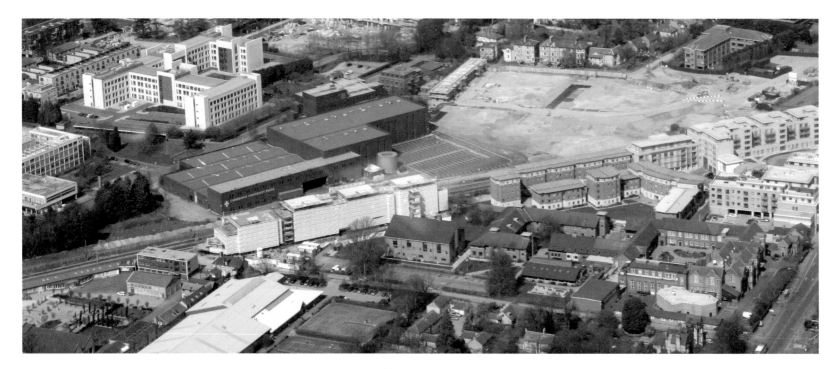

Above: Cambridge University Press, the longest-established publishing house in the world, in Shaftesbury Road.

Opposite: Hills Road with The Perse Boys School (left).

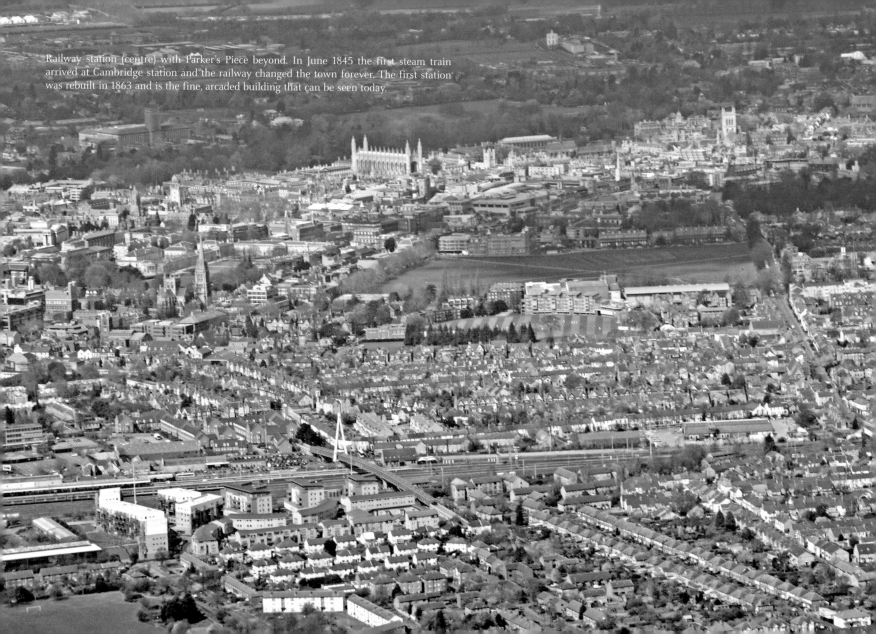

Railway station (centre) with Parker's Piece beyond. In June 1845 the first steam train arrived at Cambridge station and the railway changed the town forever. The first station was rebuilt in 1863 and is the fine, arcaded building that can be seen today.

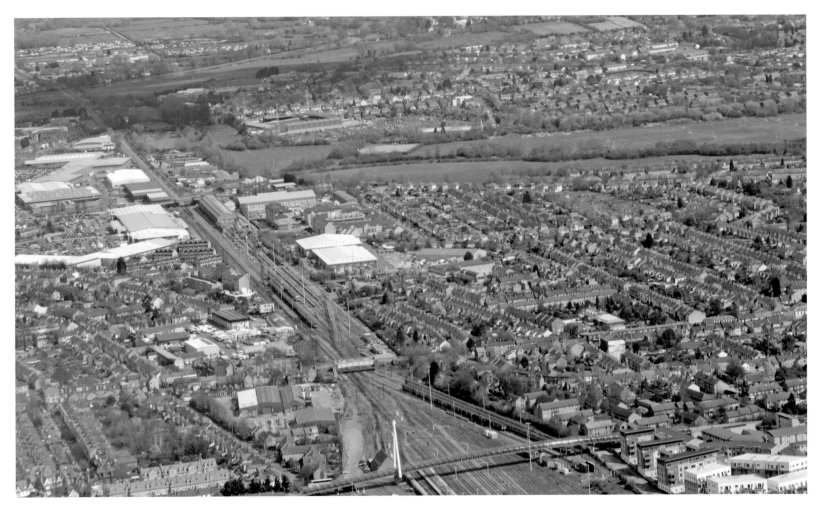

Railway station and Romsey Town where hundreds of terraced houses were built close to the railway, forming a new railway district. Abbey Stadium, Cambridge United FC's ground (centre; Cambridge City is the other football team). Right is Coldham's Common and on the left is the Coral Park Trading Centre. At the top of the picture are Stourbridge Common and (right) Ditton Meadows.

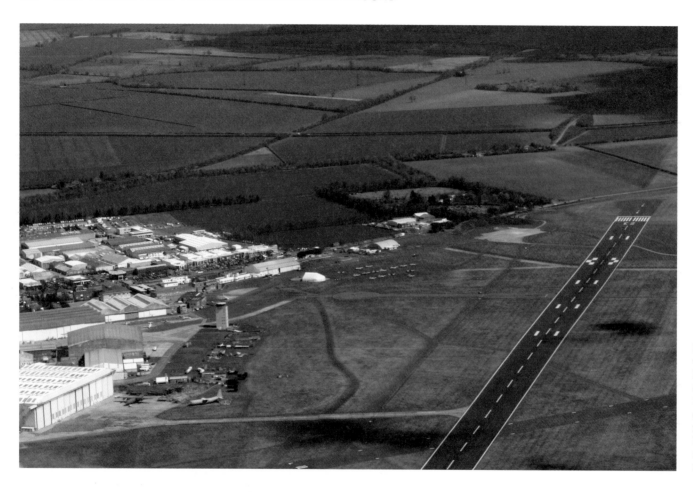

Marshall's Airport was built in 1937. The Marshall family first set up in Cambridge in 1909 with an engineering company to provide car maintenance and coach building work to the rich undergraduates of the University.

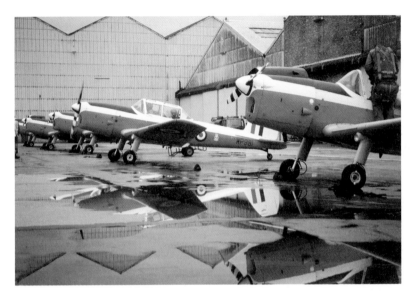

Above: Chipmunk aircraft at Marshall's Airport.

Right: Looking over Cambridge towards Marshall's Airport.

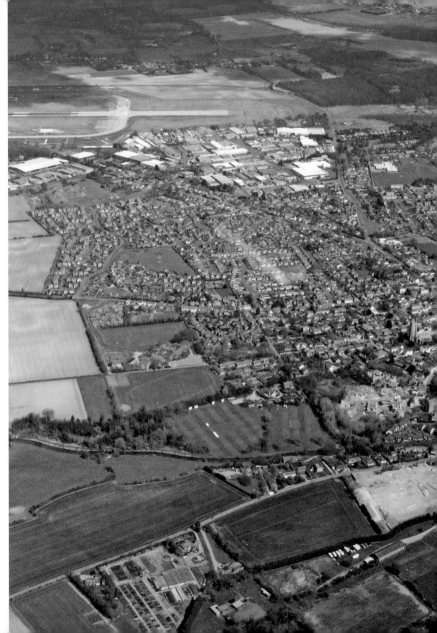

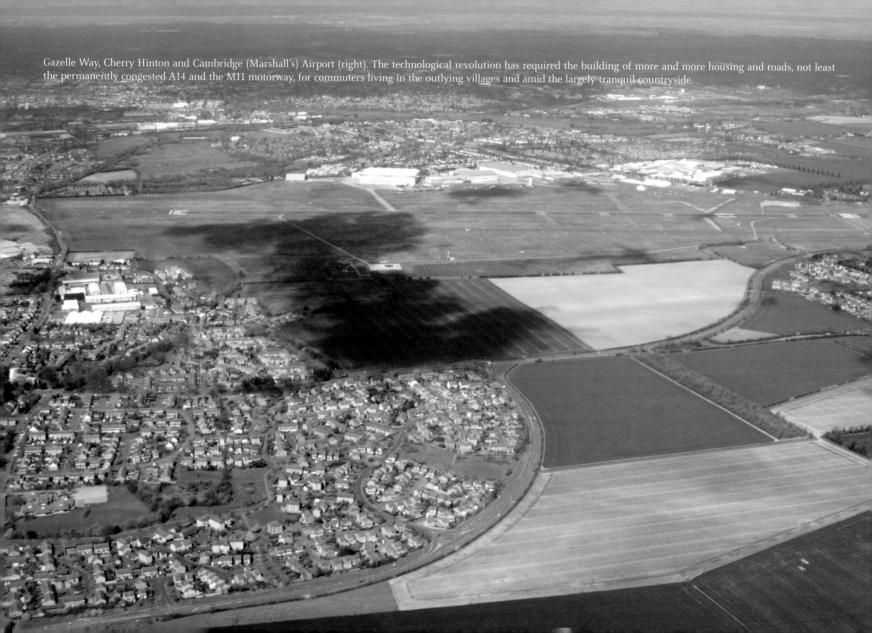

Gazelle Way, Cherry Hinton and Cambridge (Marshall's) Airport (right). The technological revolution has required the building of more and more housing and roads, not least the permanently congested A14 and the M11 motorway, for commuters living in the outlying villages and amid the largely tranquil countryside.

AROUND AND ABOUT

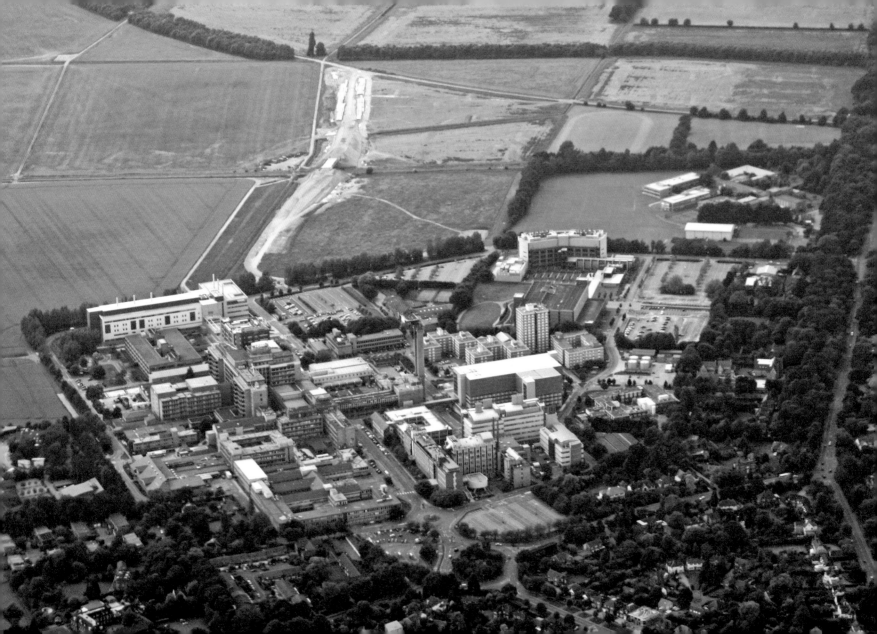

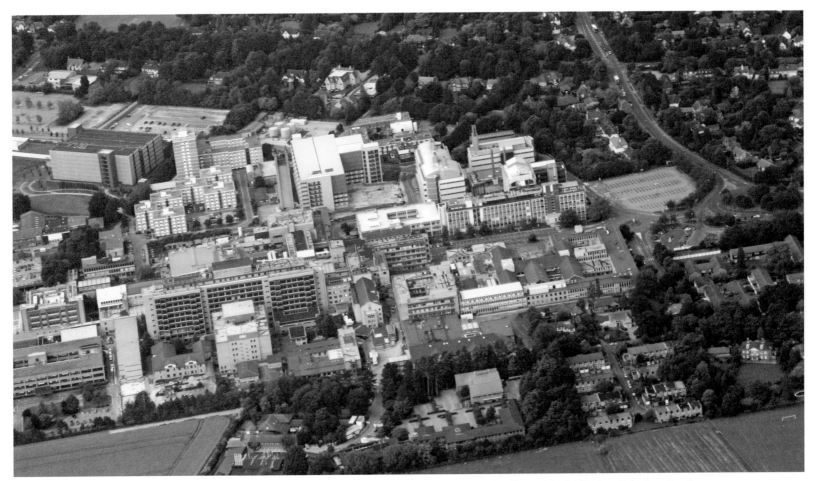

Above: Addenbrookes with Rosie (left), Clinical School (centre) and the Institute of Public Health (bottom). Hills Road (right) leads to Babraham Road.

Opposite: Addenbrookes on the southern outskirts of Cambridge, a vast complex which employs about 6,000 people, is renowned for its special skills in dealing with head injuries. The Institute of Public Health (left). The National Blood Authority and Fulbourn (right). Bottom is the Fendon Road leading off Hill's Road roundabout and joining with Queen Edith's Way at the end of Long Road (right).

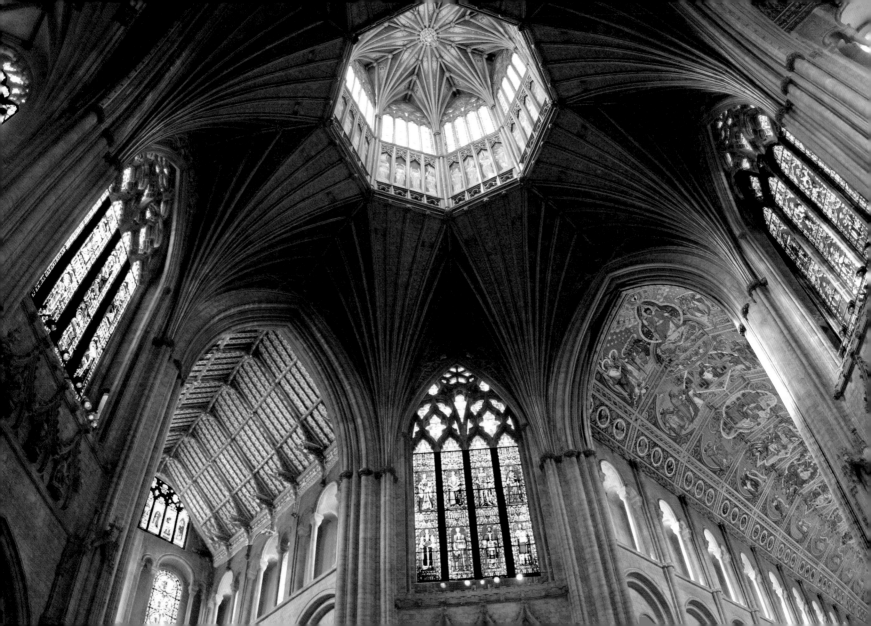

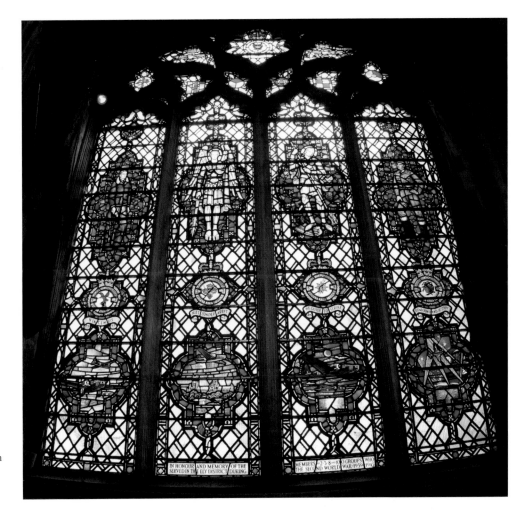

ELY

Opposite & right: The interior of Ely Cathedral. There has been a church at Ely since the seventh century, when a monastery was established by St Etheldreda, daughter of the King of East Anglia.

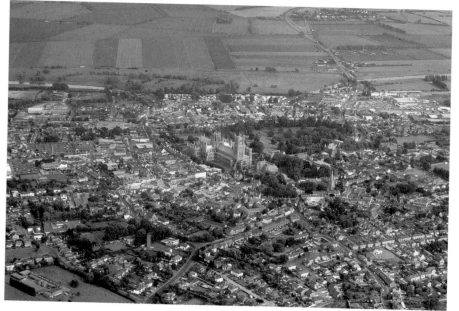

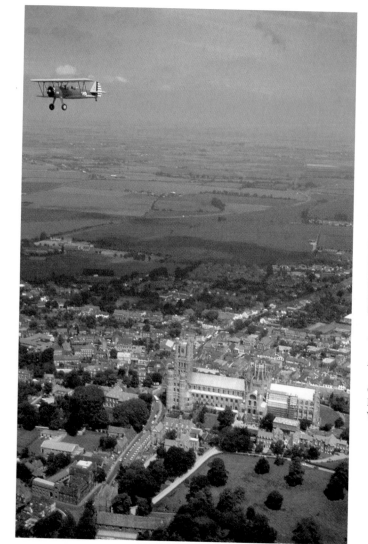

Left: A Stearman biplane is seen passing over Ely Cathedral.

Above: Ely.

Opposite: The Octagon of Ely Cathedral was built *c.* 1340 following the collapse of the original Norman tower. Eight massive wood pillars support 400 tons of glass and lead. A monk, Alan de Walsingham, was the architect for this magnificent edifice.

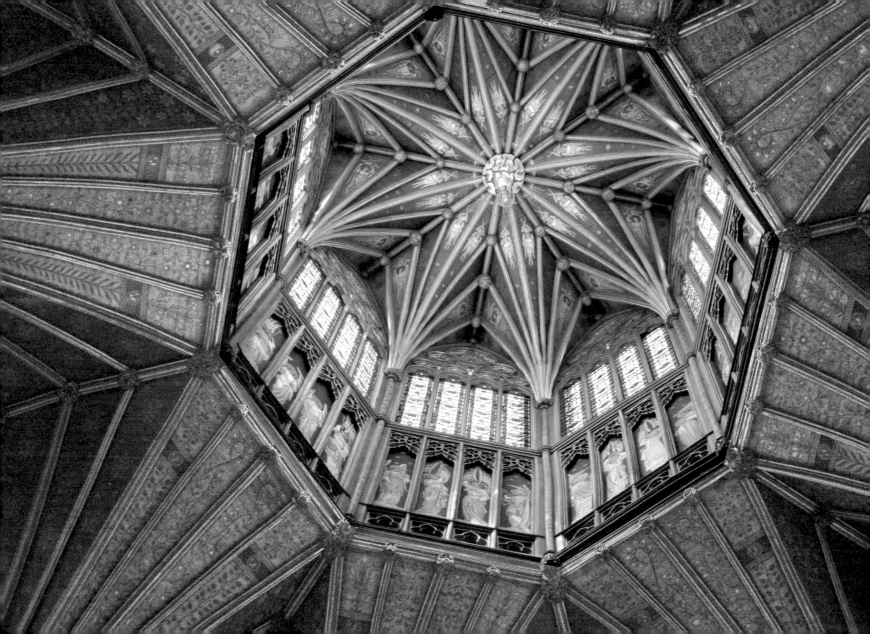

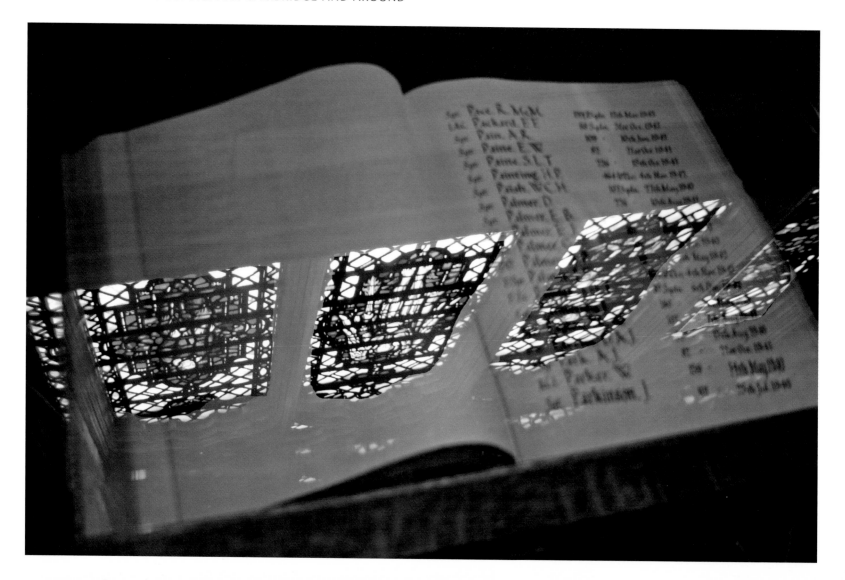

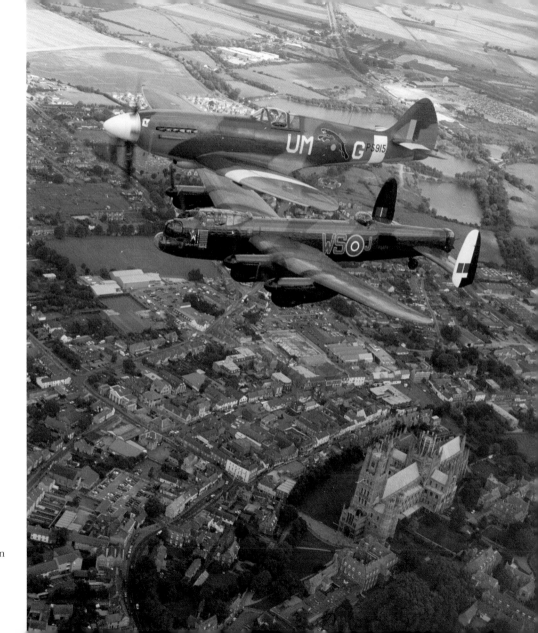

Right: A Spitfire and the Lancaster from the RAF's Battle of Britain Memorial Flight over Ely Cathedral.

Opposite: The Memorial Book, Ely Cathedral.

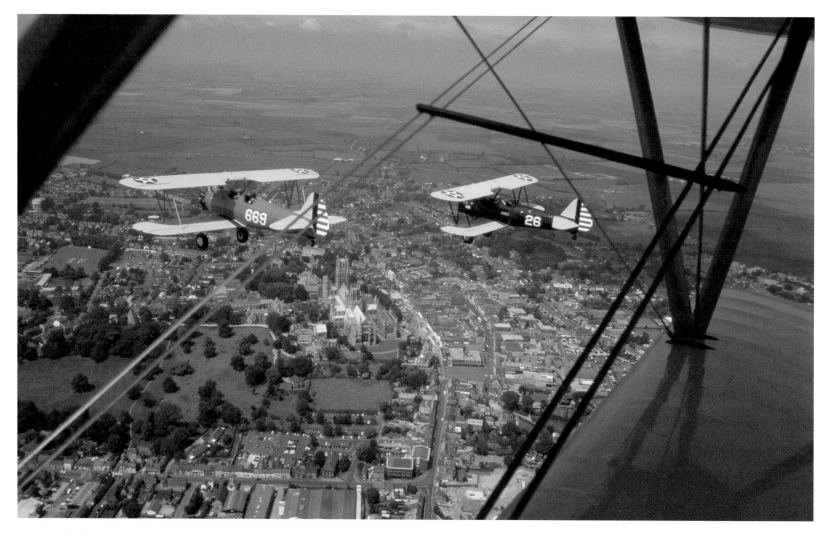

Stearman biplanes flying over Ely.

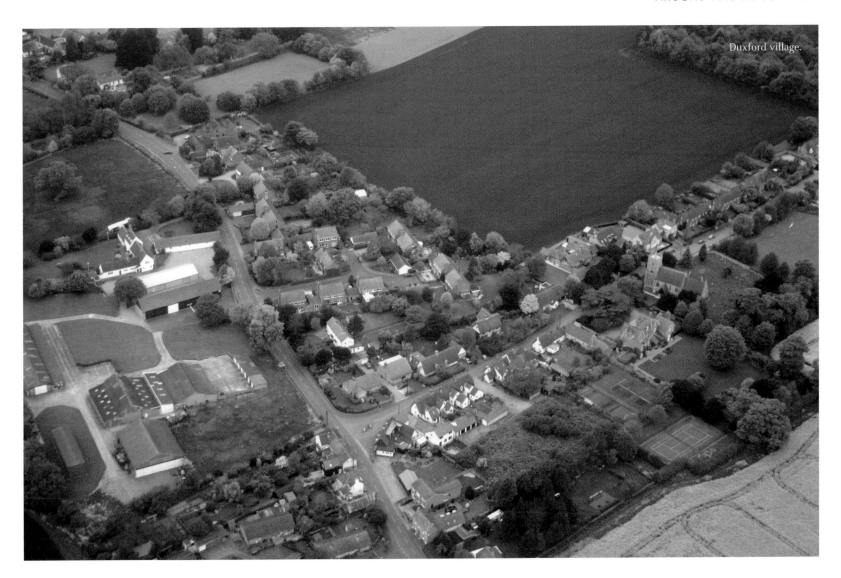

Duxford village.

Duxford can be seen at the top of this photograph. In the foreground is the junction of the A505 and A11 at Great Abingdon.

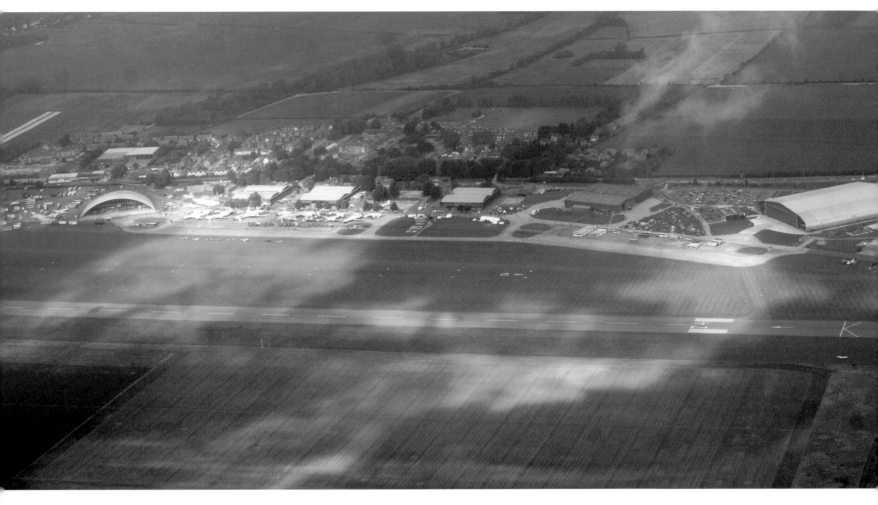

Duxford airfield, home of the Imperial War Museum Duxford and the American Air Museum.

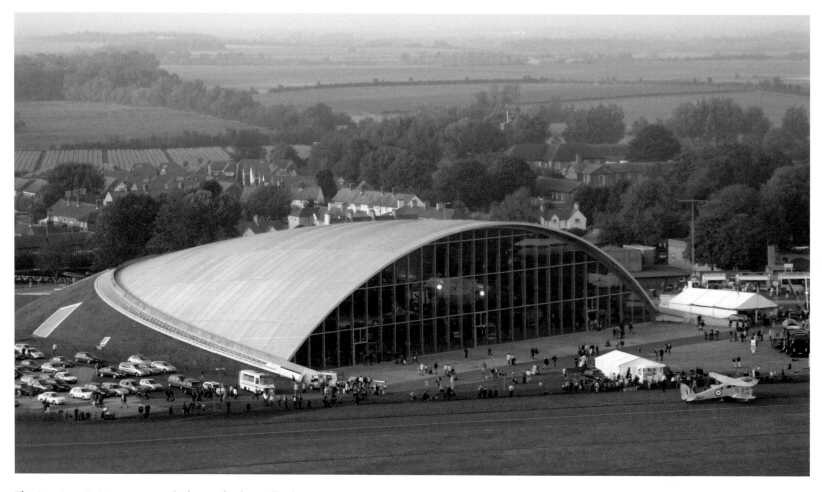

The American Air Museum at Duxford. Note the de Havilland Dragon Rapide at bottom right, used for pleasure flights.

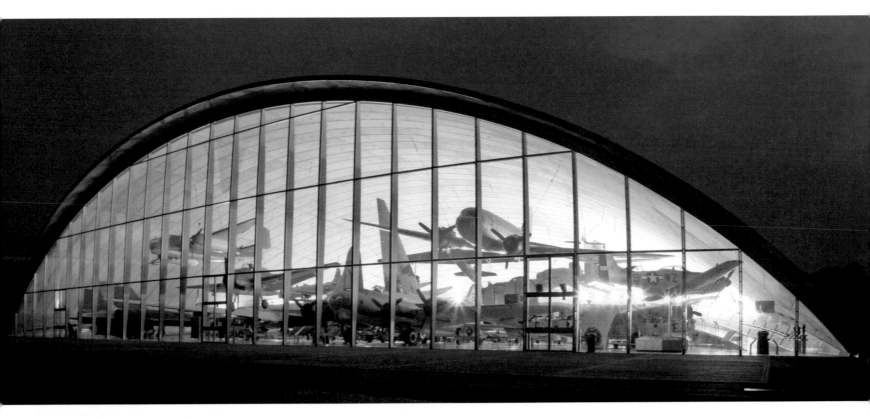

Duxford airfield at night.

Bridge over the River, Quy.

Over, Over.

The green fields of Cambridgeshire.

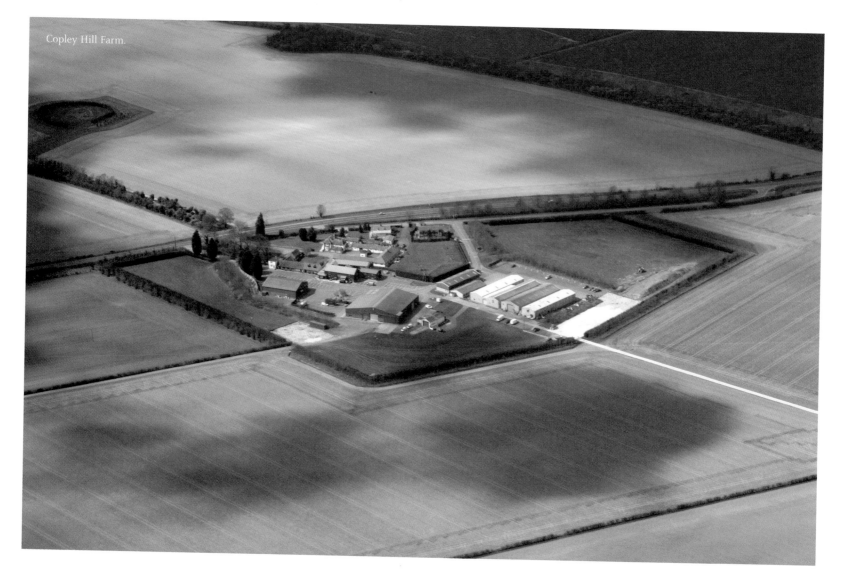

Copley Hill Farm.

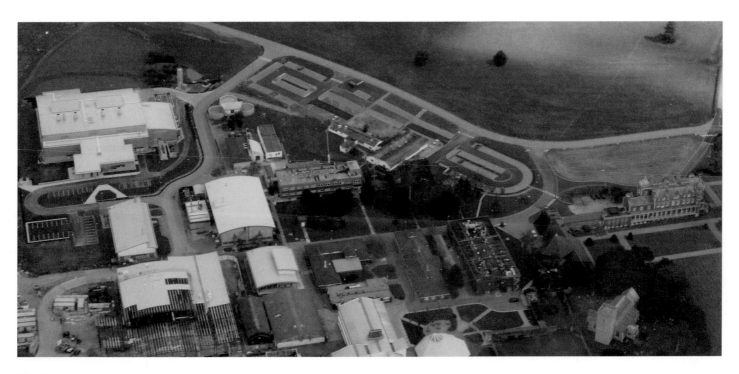

Babraham.

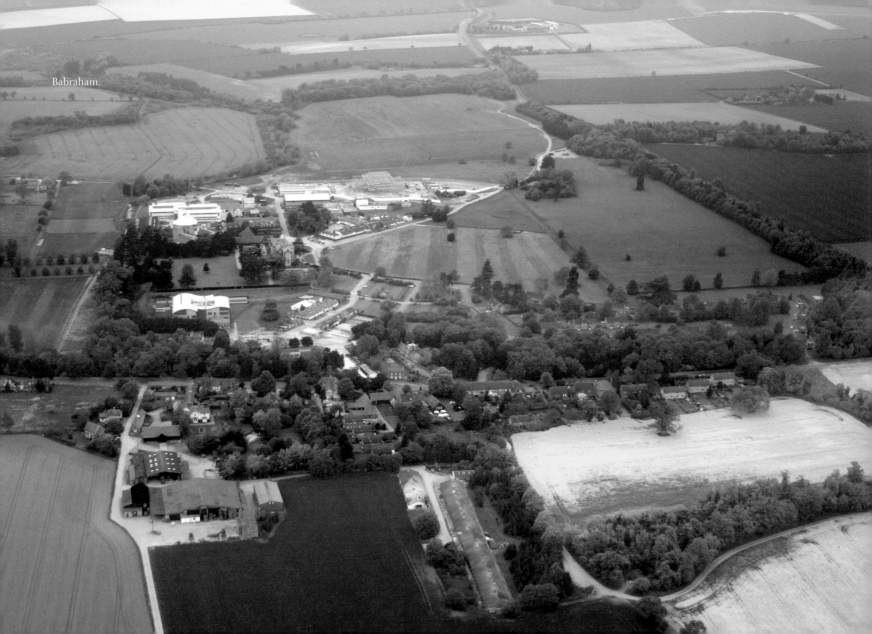

Babraham.

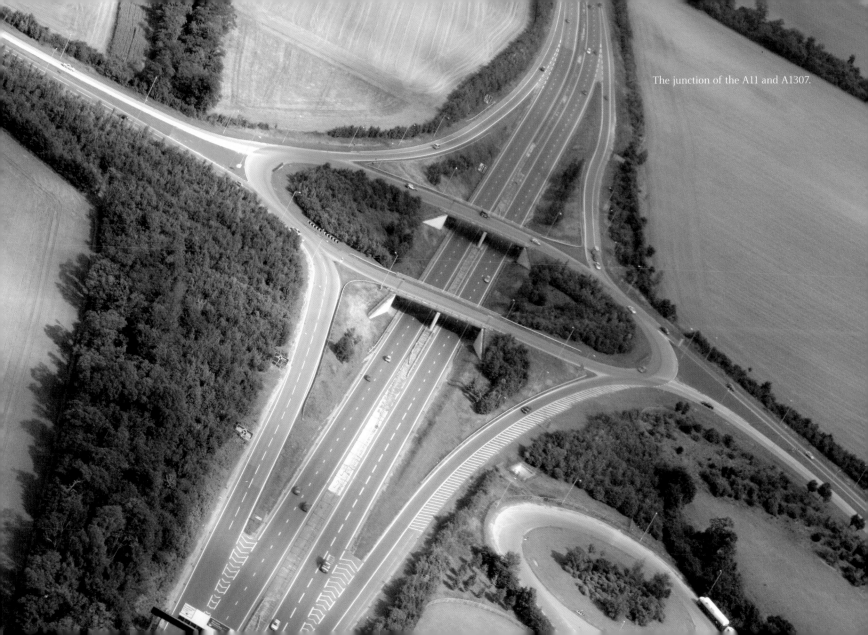

The junction of the A11 and A1307.

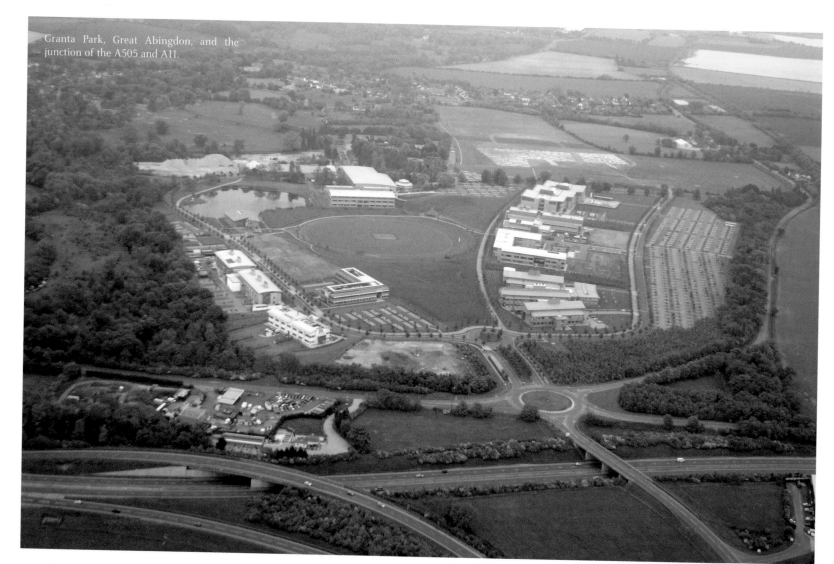

Granta Park, Great Abingdon, and the junction of the A505 and A11.

Linton.

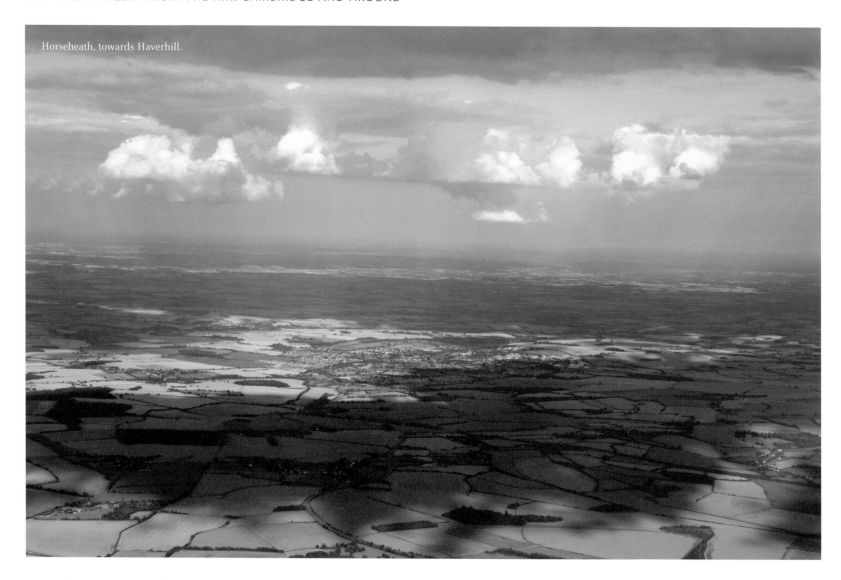

Horseheath, towards Haverhill.

Fowlmere.

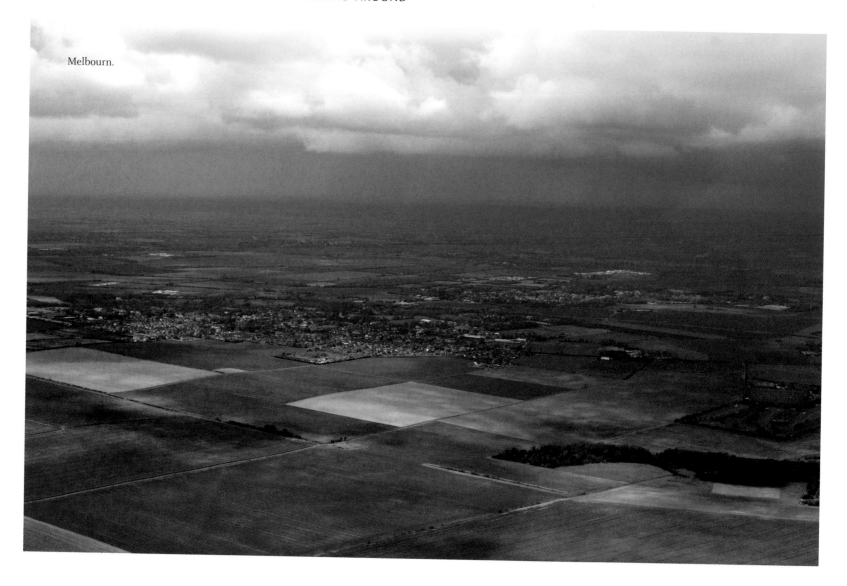

Melbourn.

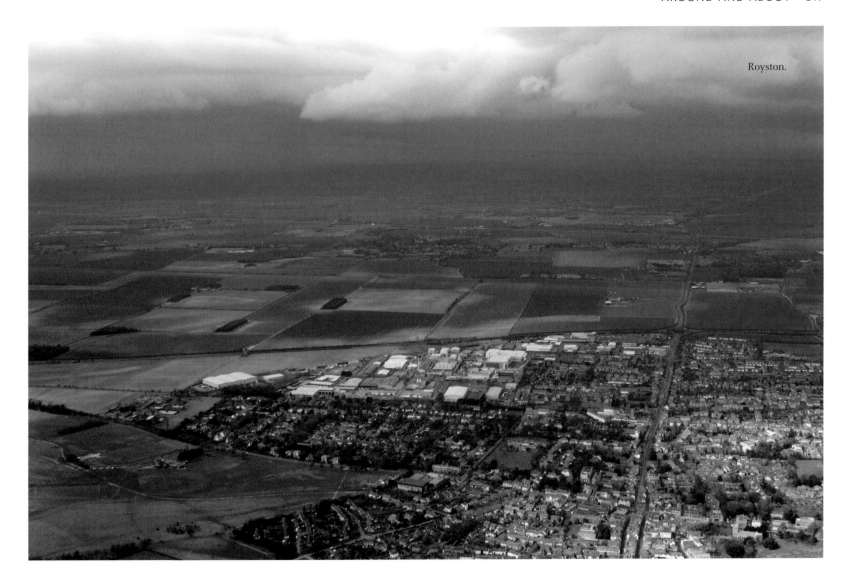

Royston.

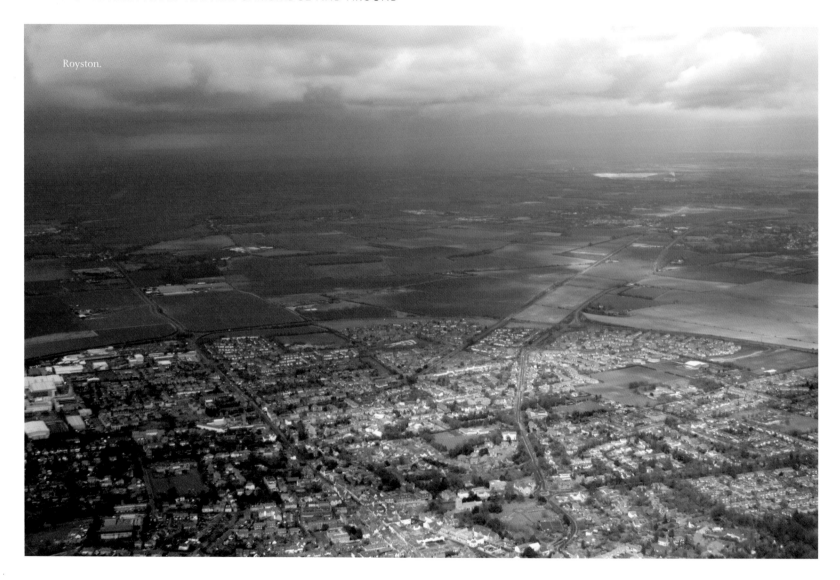

Royston.

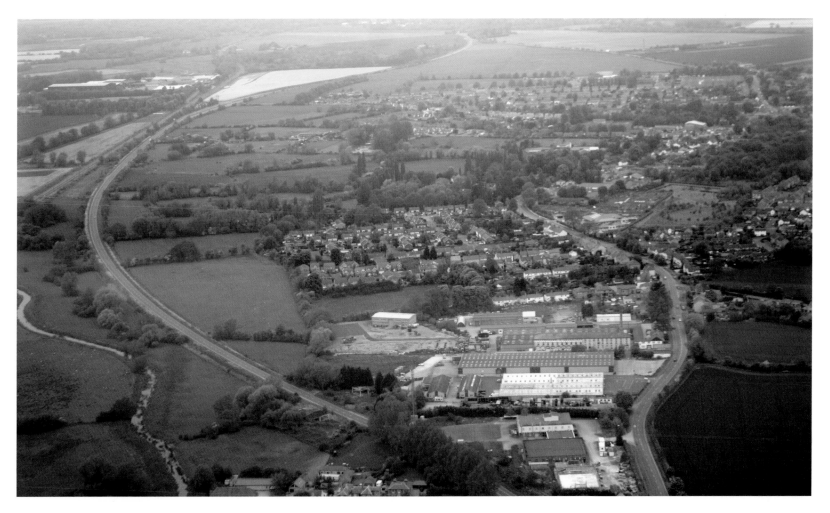

Sawston.

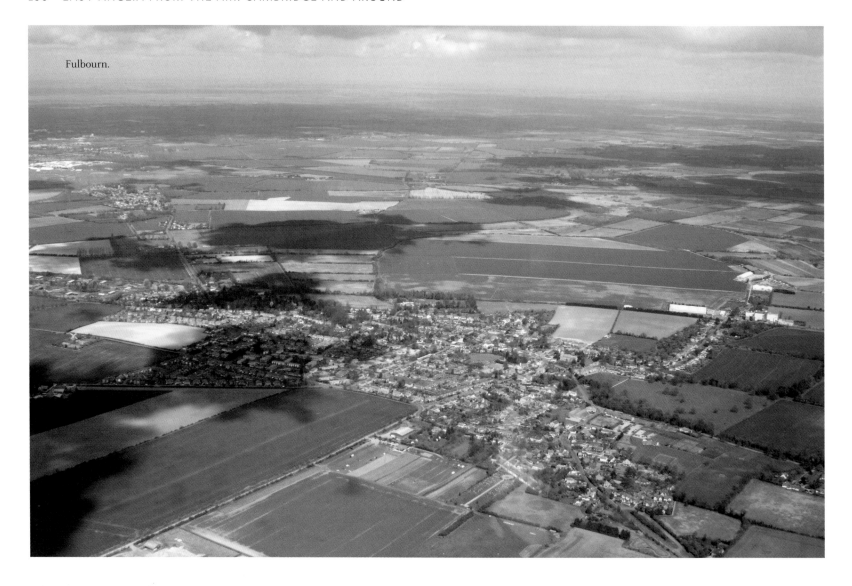

Fulbourn.

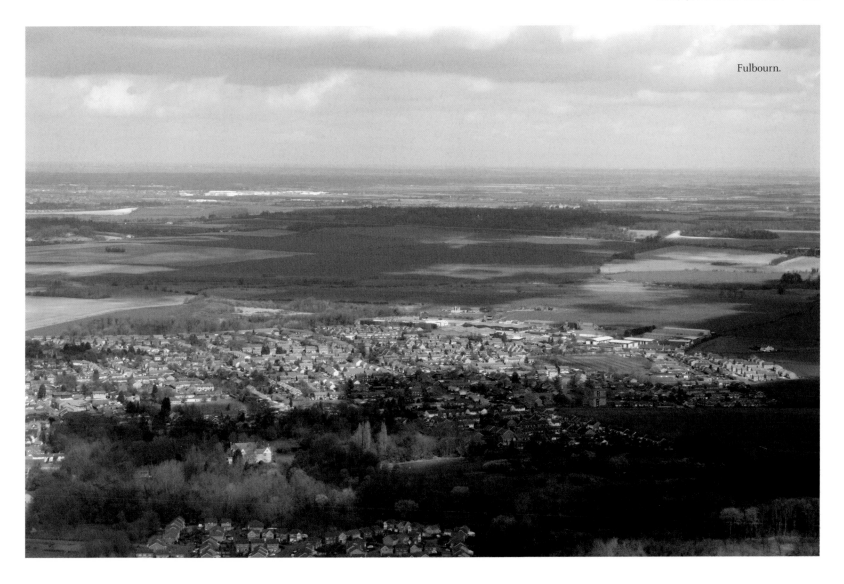

Fulbourn.

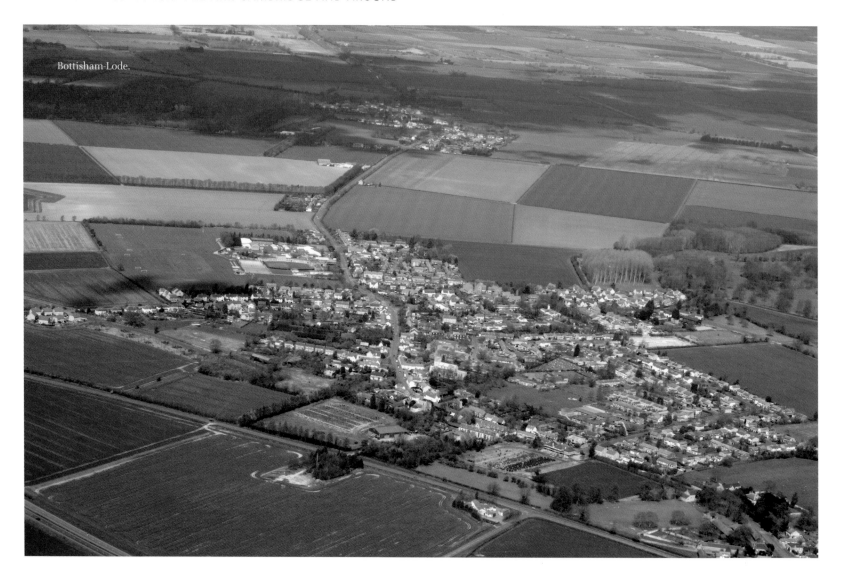

Bottisham-Lode.

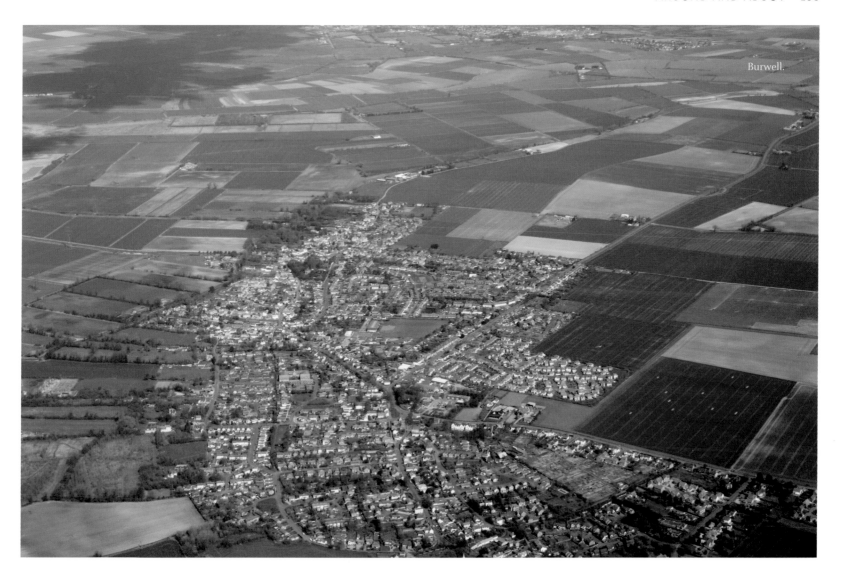

Burwell.

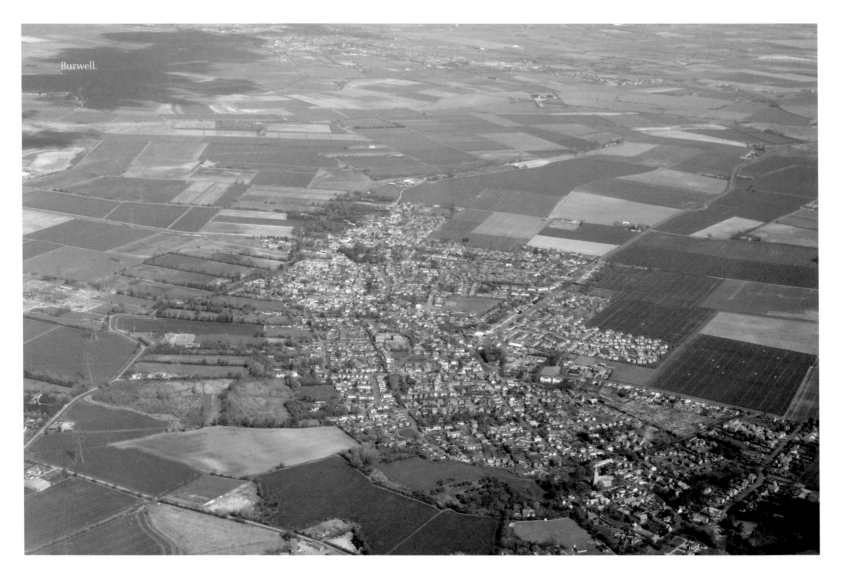

Burwell.

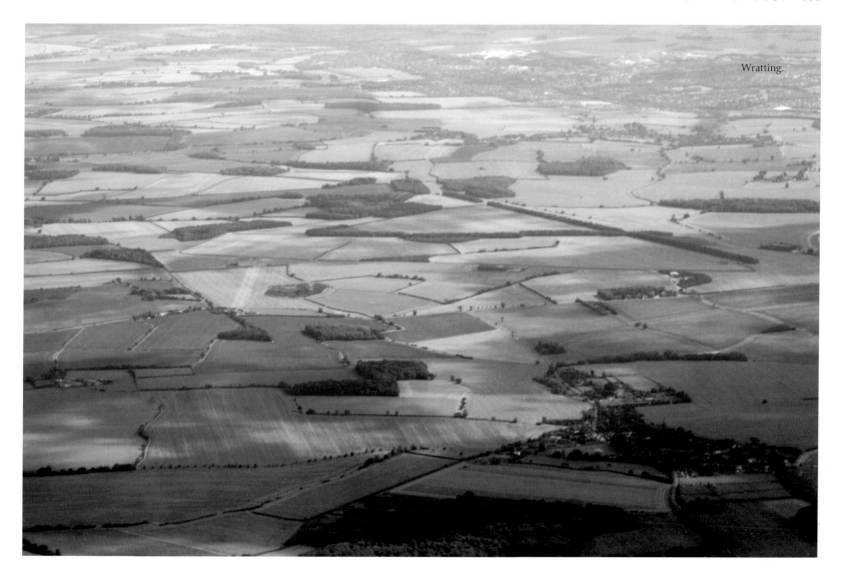

Wratting.

Wratting Common.

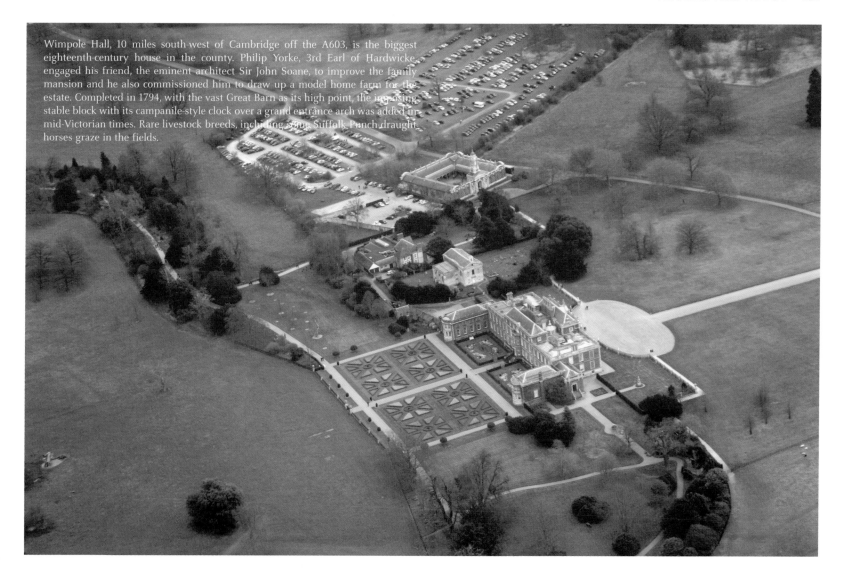

Wimpole Hall, 10 miles south-west of Cambridge off the A603, is the biggest eighteenth-century house in the county. Philip Yorke, 3rd Earl of Hardwicke, engaged his friend, the eminent architect Sir John Soane, to improve the family mansion and he also commissioned him to draw up a model home farm for the estate. Completed in 1794, with the vast Great Barn as its high point, the imposing stable block with its campanile-style clock over a grand entrance arch was added in mid-Victorian times. Rare livestock breeds, including some Suffolk Punch draught horses graze in the fields.

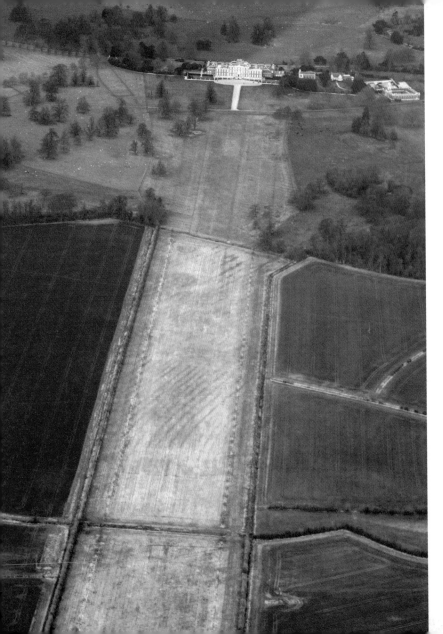

Another view of Wimpole.

BIBLIOGRAPHY

Arbib, Robert S. Jr, *Here We Are Together* (Longmans, Green & Co., 1945)

Boyd, Stephanie, *The Story of Cambridge* (Press Syndicate of the University of Cambridge, 2005)

Carter, Liz, *Cambridgeshire: Living Memories* (Frith Book Company, 2004)

Freeman, Roger A., *Britain The First Colour Photographs* (Blandford Press, 1994)

Humphry, G. M. (MD FRS), *Guide to Cambridge* (1886)

Long, Peter, *The Hidden Places of Cambridgeshire & Lincolnshire* (Travel Publishing Ltd, 1999)

Pevsner, Nikolaus, *Cambridgeshire* (Penguin, 1954)

Preston, John D., *A Day At Cambridge*

Smith, Ben Jr, *Chick's Crew: A Tale of the Eighth Air Force* (Privately Published, 1978, 1983, 2006).

Tully, Clive, *Francis Frith's Around Cambridge* (Frith Book Company Ltd, 1999)

Willis Clark, John, *A Concise Guide to the Town and University of Cambridge* (Bowes & Bowes, 1936)

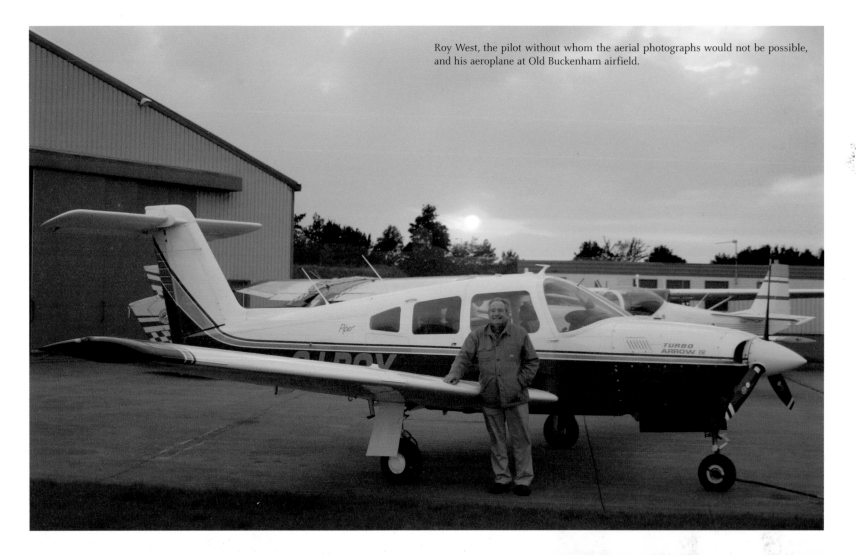

Roy West, the pilot without whom the aerial photographs would not be possible, and his aeroplane at Old Buckenham airfield.